Life Comes Free

Life Comes Free

Pictures, Poetry and Prose

by *Roverti*

Published by Lily Neal 2020
Copyright © Trevor Germon 2020

ISBN 978-0-9956661-7-7

Printed and bound by
Short Run Press, Exeter, UK

CONTENTS

Part 1: LIFE COMES FREE

Introduction

This little book comes about as the result of a terrible tragedy and a consequential pilgrimage.

 It is part of an attempt to confront and express both deep grief and sorrow. It endeavours, however, to reach out in gratitude and wonder – through 'the rose of memory', poetry, prose and pictures – to life's 'magic moments', and to pay tribute to all those, past and present, who have contributed in so many different ways to making me who I am.

It is written in the belief that night *will* be followed by day, that we are all the fruit of ancient family trees and that all of us are born to add, in our own inimitable way, to the ongoing process of creation, in which each precious life comes free.

Life comes free

Life comes free, a gift to you and me,
expressly given, with the abounding joy
of Nature's call to girl and boy;
that calling is hereditary.

Forever, it seems,
life's patterned seeds must pass
from parents, nourished by the earth,
in the recurring miracle of birth,
and love that's shared by lad and lass.

Through myriad lives, much laughing, weeping,
muted moaning, silent sighing,
daytime dreaming, barely-waking sensual sleeping,
(doubts and sorrows notwithstanding –
most allayed with careful keeping)
life's revered lines run long and deep,
a fulsome, glowing harvest reaping.

All are stowed in heaven's starry clime,
a cherished hereditament, composed of those
who walked the earth before our time,
and gave our waiting hearts a start.
They set the beat. They set the beat.

So, I am proud that I am kin,
to Aaron, Mary, Charlie, Annie,
through my parents Walter, Win.

Life's hereditary, and it comes free.
We are part of a family tree,
that has a story of its own.
A tale that's not devoid of mystery,
and, sadly, sometimes tragedy.

How The Paintings Came Into Being

Christmas 2016 had not been the best of times. The weather was cold and wet, the wind blew, and the Derbyshire Peaks when we visited were not as welcoming as usual. Nevertheless, on the last day of the year I was looking forward in hope to the start of 2017, cheered by the prospect of new ventures and of opportunities to enjoy the company of friends and a growing family of loved ones. There would be more choral singing, new ideas, a renewal of creativity. 2017 would be a good year.

It would also mark, however, the centenary of WWI's pitched battles in France and the carnage in the trenches, especially at Passchendaele. I would, again, be reminded how Rudyard Kipling lost his only son, John; how the poet Edward Thomas died at Arras; how my uncle Rod, who sent little cartoon drawings to his younger sister, my mother, was gassed in that war. On 11th November I would remember again my grandmother Annie shedding bitter tears as she listened to the radio broadcast from The Cenotaph.

On Monday 30th January, at about nine o'clock in the morning, two young policemen came to our house to deliver a short, shocking, barely believable message. Our younger son Richard was no more. He had died early that morning. Stunned, we sobbed, cried and held each other close.

"No, no, no!"

Surely it could not be so.

Oh, grief, how sharp is your sting; how painfully blunt is your blade!

Yet there is no denying that life as we know it ends, for all mortals, in death.

The funeral was delayed until the spring. We said our painful goodbyes and faced the new reality: a sadly ruptured, diminished and disfigured future.

But, as it always does, time ticked by. Finally the tears stopped and birds began to sing . . .

I needed to mark my loss and to remember Richard in some special way.

For the next year and more I made a ritual of spending much of each day alone in my studio at Barley Lane in Exeter, making works of art. Guided by feelings, instincts and thoughts, grieving for my lost son, yet still a part of an ongoing world, I tried to work systematically through to the middle of 2018. By then I had produced about a hundred paintings. Most of these were put on public display at the studio in September 2018.

They were there when the centenary of the World War One Armistice was celebrated on 11th November, and for the foreseeable future they will remain on view in memory of Richie, our shy lion-hearted boy, who brought so much to our family life. He left us bereft, but with memories, and with two dear grandchildren to treasure.

2018 came and went. 2019 has gone. We live in a new decade, and it brings fresh hope. It is time to paint, to write, to tell a tale or two, to listen and to participate, as the story of an ever-changing world unfolds.

What follows is an *ad hoc* patchwork of pictures, poetry and prose put together after the exhibition.

18th February 2020

THE PAINTINGS, POEMS
AND OTHER WRITINGS

Right Start

Where to start? A ridged rectangular piece of white PVC, about one foot wide, comes quickly to hand. Can I find in it a sense of direction and purpose? To me, white seems, naturally, to call forth colour. Let's complement the whiteness, add colour, perhaps, a hint of a rising sun?

Two blocks of brightness were added. Immediately, the piece became a beginning; a clear indication of movement onward.

It seemed right.

The all-important first step had been taken; a start had been made.

La Mer et La Lune

I discovered a discarded noticeboard. It was made from wood and covered with felt, dark blue in colour. The frame was light grey aluminium. Where would this 'debris off the wall' lead?

I recalled Richard talking about an adventure which he had in his early teen years. He had been a member of a four-man yacht crew on a voyage from Plymouth to Cork in Ireland and had spoken to me of his experience of being on deck, alone, at night.

Ralph Vaughan Williams' *Sea Symphony* came to mind. The second movement, entitled 'On the Beach at Night, Alone' set my mood as I sought to create what became *La Mer et La Lune*.

Sometimes when all at sea, we seek the moon's soft glow . . . so much to take in tow, so much we cannot know. Through time we come and go . . . Always, it seems, we trust that the tide will turn, take us to an ultimate goal, assuage innate yearnings.

Is it possible that a few shreds of gold will so endow a surface of doctored-blue, that it evokes timeless poetry, or the symphonic swelling of a boundless sea? Did Vaughan Williams glimpse the ghost of a teenage boy squatting upon the deck of a small yacht, his eyes filled with wonder? Was there some fathomless foreboding lurking, lying deep, that our – so dear – young son could not see?

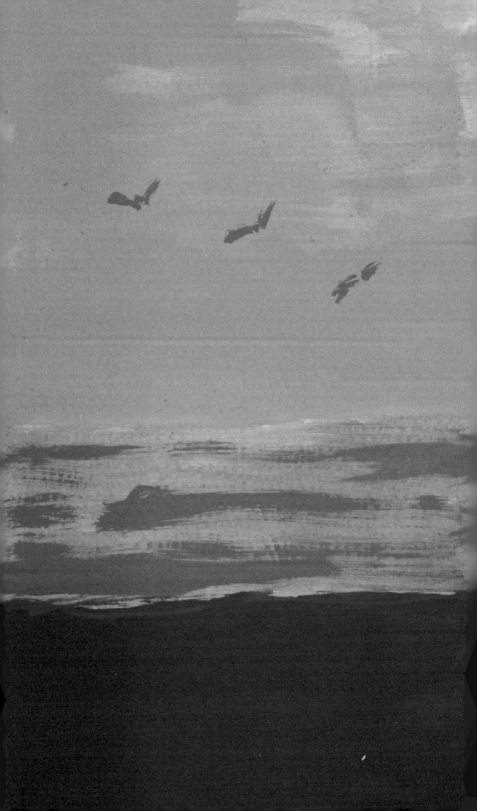

Bluebirds Over

It is easy to be nostalgic about the sea. For me, it conjures visions of white cliffs, the English Channel, the Second World War, the comforting tones of Vera Lynn, and her assurance that there will be *Bluebirds Over* . . .

But Dunkirk happened. On an early June evening in 1940 my sister Marge took me to Newton Abbot railway station where, on Platform 9, we saw a trainload of bedraggled mud- and blood-stained soldiers emerge from a train. They threw French and Belgian coins into the welcoming crowd. But the bombs fell, the guns roared, planes and ships came and went, winning or losing in the Channel, until the sirens sounded a last All Clear and my father's black metal helmet (with a white 'R' on the front) was finally consigned to the attic.

Oh, yes! And, on the evening of the 8th July 1945, a few days before my twelfth birthday, I sat on one of the lions in Trafalgar Square celebrating VJ Day with my evacuee friends, the Smiths, along with thousands of survivors of that second great war. Who would deny that *There Will Always Be an England*?

Perhaps, when peace prevails, the bluebirds fade into the blueness of a placid sky.

Seeing the Blues

The end of the war and the ongoing effects of the Yankee friendly invasion saw a blossoming of blues music, sweaty jazz and nostalgia. The pop-corn, gum and Camel cigarettes soon disappeared, but in the cinema the dancing feet of Fred Astaire continued to portray, and to foster, an American Dream.

My sister Marge declined an invitation to become a GI bride, possibly, for a while experiencing her own kind of blues. She never became Mrs. Greenleaf. Instead she married – and shared the rest of her long life with – Brian Heath, her very own Mr. Right Guy! They were a wonderful, jolly couple; kind, caring, and resourceful. They were an example to us all, and the sort of people described by the American poet Marge Piercy in 'To be of use', a poem from her collection *Circles of Water*. (Try reading it!)

Unpredictable

Will we be *Singin' in the Rain*, celebrating a *White Christmas*, or pleading *Bring Me Sunshine*?

But it is not only the weather which is unpredictable. No-one really knows about tomorrow. We have to settle for whatever the heavens deliver, knowing that there will be grey skies, some rain, or even snow. There will be bits of white cloud and, if we are lucky, some sunshine ahead, whenever. Rather predictably, there are countless poems about rain, and probably even more about the unpredictability of Spring (prone, always, to be fickle).

And So it Goes . . . no one really knows . . . be patient, raise a wettened finger, and see which way the wind blows.

Ascent

Darwin saw the ascent of humans . . . from primeval sludge through *homo erectus* to *homo sapiens*, sentient beings standing tall, always reaching, so it seems, for the sky, living beyond a biblical allotment, scoring 100-plus, becoming centurions at heaven's gate, striding on the moon, probing Mars and crowning (or perhaps enslaving?) themselves with artificial intelligence.

Yet, still, we wonder at *The Lark Ascending* and we may easily be moved to tears by Samuel Barber's *Adagio for Strings* or Elgar's *Enigma Variations*.

The really big questions remain unanswered . . . remain unanswered . . . remain.

But don't most of us believe, that, one way or another, come the end, we will ascend?

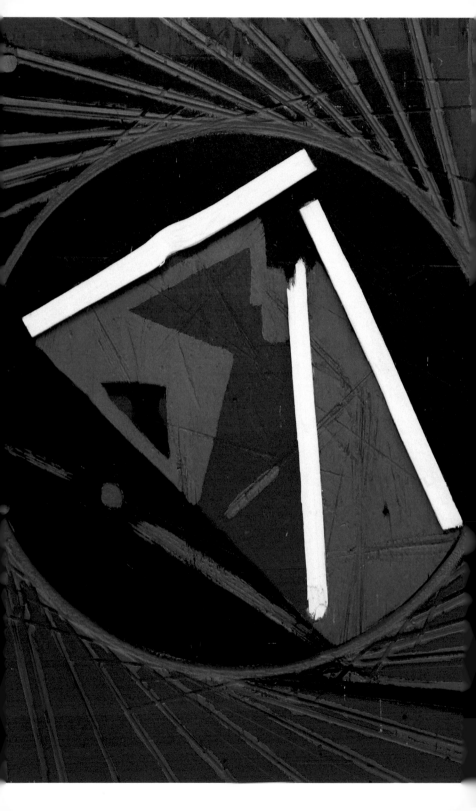

Industrial Revolution

Ascending man discovered the wheel and how, using fire and water, he could produce steam and electricity. He became a living powerhouse of innovation and production, an undreamed-of creator of things bright and beautiful, dark and dangerous, all packed with fresh potential. So ascending man, 'fly-wheel' man, powered a revolution.

Is such a revolution an integral part of what is in essence an evolutionary process? What part was played by the early abolition of serfdom in Britain, the labour shortage caused by the Black Death, the Reformation and the rapid rise in the British population in the eighteenth and nineteenth centuries, in the greatest 'spin' that the world has seen?

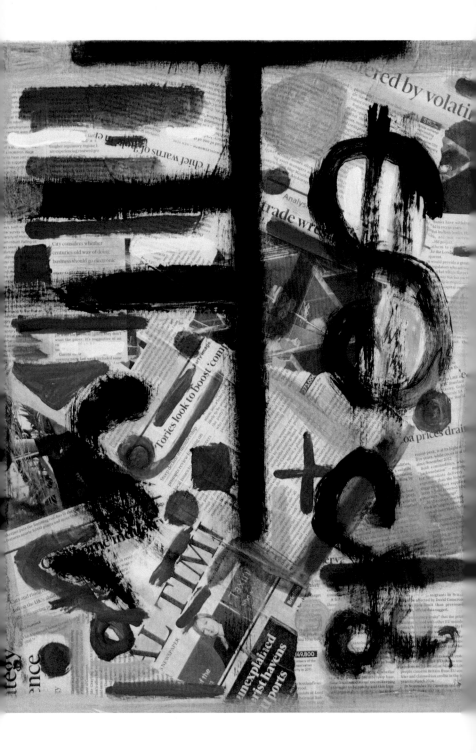

Money

The Industrial Revolution required money, a break away from barter, a means of exchange, a unit of account and a store of value or capital. Coinage and paper money were supplemented – and largely replaced – by credit and financial systems. This facilitated and fostered new technologies, science and engineering, and drove invention and innovation.

Times become increasingly financial. New offices and banks dwarf ancient cathedrals. Old superstition gives way to new, and no-one can be sure what value money really holds in store.

What will the bit-coin era bring, apart from an increase in guessing-games and gambling?

Nevertheless, money has proved to be an important tool in human development: it needs to be handled wisely, with care and respect.

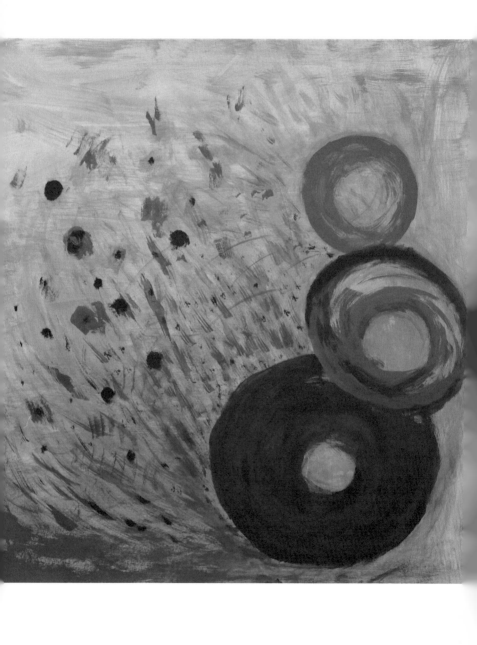

Child Play

I play like a child with the colour blue. My brush chases after shapes and forms that flow as I move around a rectangle of space, to fill, play the game, to tell the tale in multiple shades of blue. This can be hard work – but finding the child in me is a wondrous reward.

There is something special about stuff coming 'out of the blue'. Life, at times, *can* be child's play, and blue is such an invigorating colour.

For an adult it can be very cathartic, at any age, to choose a single colour, take a brush and play enthusiastically with the imagination. It can also be a great way to relax from playing on, or with, words!

Blue Cut

This death-bed-wood-board was made from trees once stacked with sap, bearing leaves, and waving felicitations to the sun. The lacerations were caused by the biting teeth of an industrial saw; teeth that had bitten through limestone, granite, marble; stone from Dorset, Bath, and Dartmoor.

Perhaps blue paint will salve the cuts, and cause the long-dead wood to know again the lure of summer skies; a sort of 'out-of-the-blue' redemption, vaguely (tenuously?) connected to the pulsing of a distant mighty sun.

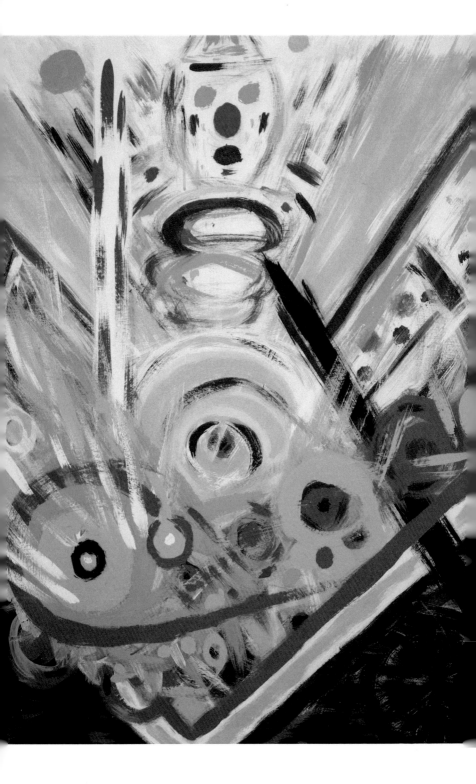

Brassed Off

Many people, especially the local miners, were *brassed off* when the coal mine at Grimethorpe in Yorkshire was closed. But the stalwarts of the colliery band stood fast and continued to blow the sounds of brass music countrywide. Ultimately, they carried off a grand prize at the Royal Albert Hall in London.

A story based upon these events was made into a film which features an ailing conductor and several wonderful characters who at times are beset by human fears and frailties, and who endure many setbacks and hardships. But with hope, humour, music and true camaraderie they find consolation playing in their brass band. Blow by blow, this is a telling tale, full of life's stuff, with very little nonsense.

To do the film justice the painting should be at least twice its size! Do see *Brassed Off*, and enjoy a feast of beautiful, bold, brassy moments in time.

The northern working man played by Stephen Tompkinson, especially the episode when he was working as a clown, made me feel very close to Richard (who spent most of his adult life north of Birmingham).

Behold!

Just one flap of an owl's wing as it glides through the dusk of eventide. It is alerted to sounds that humans cannot hear and it sees many things that they cannot see. Such sensitivities secure survival. Behold! Here is wisdom on the wing. See the searchlight power of those yellow ochre eyes.

To wit and to woo, this bird is free to pry, to prey; to live at the edge, both night and day.

One was even said, long ago, to have been found at sea in a pea-green boat, with a cat for company . . .

In Brno in the Czech Republic the symbol of Masaryk University (*masarykiana brunensis universitas*) flaps invisible wings and celebrates a hard-won centenary. I remember the words of my poem 'Eulogy to Harmony'* and the life-long lessons of the Brno International Summer School I attended in 2010.

Nazdravi, Brno! *Děkuji*! It will soon be the thirtieth anniversary of my first trip to Brno.

* Included on page 194 of this book

Piece Work

Here is featured a man of many parts; a piece-full assemblage, strangely solid, rather staid, and made, perhaps, to symbolize some hitherto unrecorded working-class . . . post Marx?

Is Marx connected to the aptly-named Scotsman, Adam Smith, who studied the manufacture of pins, made money and in the process gave the Industrial Revolution a huge shove? Not only Greeks have *eureka* moments!

Spot On

As yet, there is no red dot with this singular bright spot. But I could be sold . . . on the idea of a well-rounded orange (or yellow) blob placed, with great care, upon something rectangular, narrow, smooth and black . . . if it were really 'spot on'.

Something that is 'spot on' has the ultimate seal of approval. When put on the spot, it is often difficult for us to award such an accolade.

Golden Deity

The visage of an ancient god glistens with gold.
By this face an ancient faith is sold.
In the light of this great deity, stories are told,
scrolls are unrolled,
short lives unfold
and the world grows old.

What happens to such a deity
in a godless age, or when the world dies?

Transit

Some people will have no truck with 'movement' of any kind:
Seeing no need to go, they prefer the *status quo*.
They like to stand fast, hold tight.
They have no fear of being left behind.
They see no need to pass across,
or over, or through, from place to place.
The old familiar things
are a static 'transport of delight'.

Passing Time

With age, it seems, time ticks more quickly.
It is no longer linked so inevitably
 to the tock of history's clock.
Tick, tock, tick . . . it is the 'tock'
which softens passing time,
dispensing a subtle moment of . . .
hesitation.
Will the next moment arrive on time?

The guttural 'tock' is longer than a tick.
Briefly, it allows the listener
to contemplate the tick's significance.
Tick, tock, tick, tock . . .

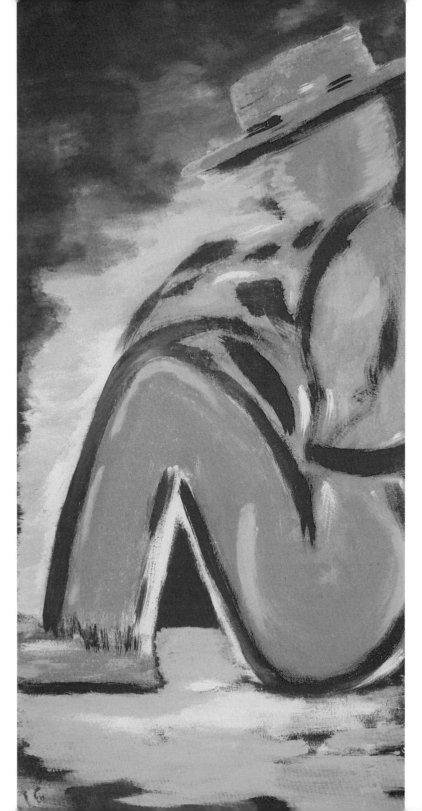

Summer Man

Some say that there is a man for all seasons . . .
When clouds and temperature are high,
the sky is mainly blue, Summer Man wears a hat.
He may neglect his work.
His preference is to lie, or sit, around
on ground that's warm and dry,
mesmerised by a majestic sun.

With half-closed eyes, he weighs
the magnitude of summer's gifts.
Sometimes, he'll hum his favourite tune,
listen to the buzzing of the bees,
sniff the scent of blossoming trees,
imagine the sound of a small guitar,
or the alluring smell of his favourite bar.

For such a man there is no plan.
He'll never need a fridge, or fan . . .
It's just so cool to be a dude:
a loose-limbed, laid-back, Summer Man,
well-attuned to the season's mood.

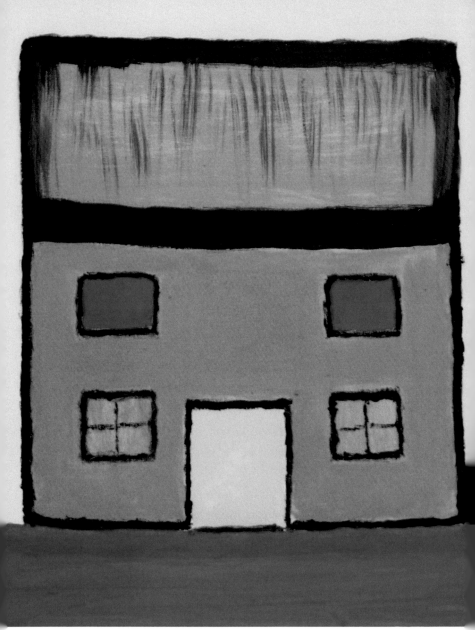

House

A house is usually a box with four sides, a roof, at least one door and a few windows. It is intended to keep people – and sometimes animals – dry and warm and it provides storage and security for belongings, food, clothes, gadgets and personal treasures.

A house may become a home shared by a family and, over time, a house becomes a repository of lives lived, past hopes, past aspirations, fears, forebodings, past comings and goings, past successes and past failures.

Houses play an important part in individual lives and in their futures. A house can make – or break. It may play a rôle, or take a toll.

Around the time that Richard and Linda's son Dan was born they acquired a detached house in Greendale Avenue, Holymoorside, near Chesterfield. In the large rear garden there was a massive willow tree, and this tree – and the garden – became an important playground for Richie's imagination. In quick time he had built a unique tree-house, with its own swing, and the garden was soon growing plenty of fruit and vegetables. More trees were planted. Paths were laid. A substantial shed was built. Here, at times, happiness and frustration lived tandem lives.

Rich loved planning and arranging visits, trips, outings and holidays. I'm sure that he often did this when pedalling his way to work or when walking through the Derbyshire countryside. This was a fundamental part of being a loving husband and Dad. And, tenaciously, he laughed and joked and ploughed his way through life's ups and downs, until the willow began its endless weep.

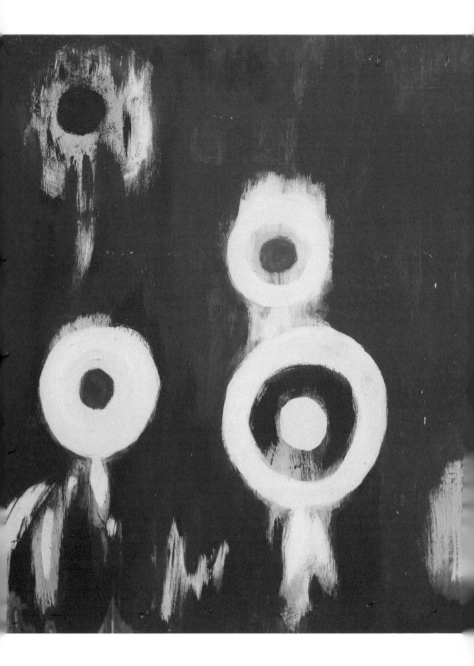

Blue Abstraction

The idea is to focus on blue;
 to let it dominate.

If, absent-mindedly,
some of this blue is struck through,
removed, replaced, by white,
to form irregular shapes,
 an abstraction is created
that is quiet, playful, thoughtful,
fetched from afar,
 yet close at hand.

Universally, blue can 'lift' a life.
At times, hold it together,
like glue.

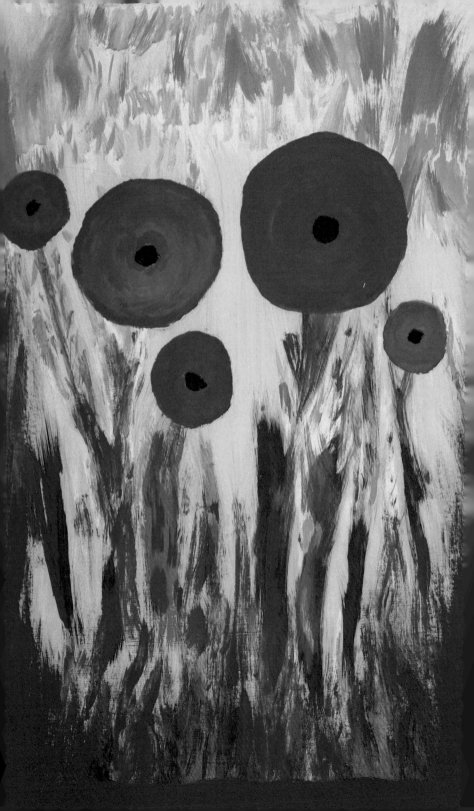

Blue Flowering

And blue may take us by surprise . . .
reappear in different guise.
As butterflies and children play,
a radiant sun, all earth empowering,
generates a new blue flowering,
in light cascading, to bright the day.

Here is summer at its glorious best,
in a sizzling, shimmering blue
that is totally beguiling.

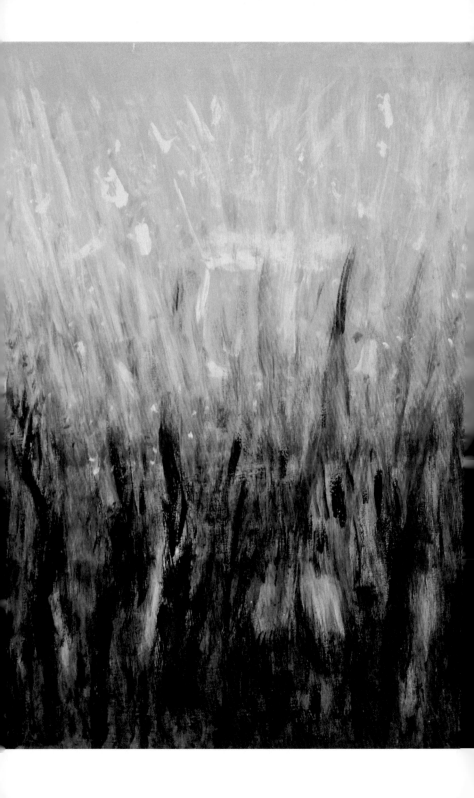

Life's Time

Green is a colour
in between yellow and blue.
It is the colour of grass,
of leaf, and emerald.
Green is where all ripening begins;
it is a product of sap,
it is not dry.
Green gives the 'go' to life's time,
endowing it with youthful vigour,
virility, and the knowledge
of by-gone growth.
Such time would not exist
without greenness.

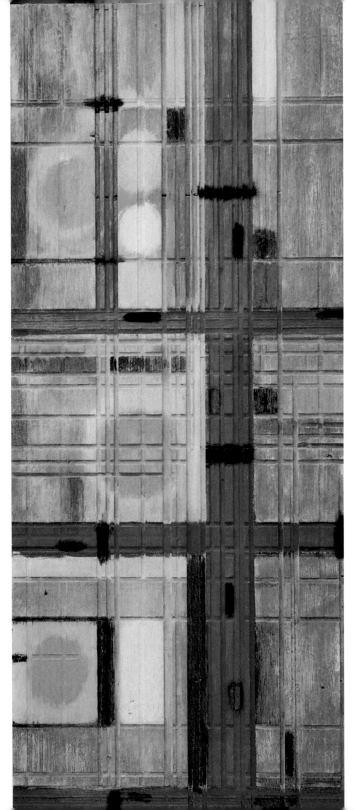

Spain

No bull: Spain has a beefy side.

The Mediterranean sets the tone, however. It is the middle C of a continuing timeless symphony. Alongside it, cultures have coalesced, great cities and civilisations have risen and fallen and races have mixed, married, traded and fought since history began.

The huge block of the Iberian peninsula hovers over, and casts green eyes on, the Rock of Gibraltar, and while Spain abuts its historic rivals, France and Portugal, there is also much that is Moorish – and not just the Alhambra.

Who could fail to enjoy the sunshine, the sights, the sounds, the Picasso-esque vibrancy of the place, all the open lightness, the occasional dark mysteries, the fruity appeal of Spain?

If you look hard, there are magical windmills everywhere.

¡Olé!

Follow the lead of the castanets, stamp your feet and clap your hands. Pay homage to flamenco!

Forget the Spanish Armada – remember Granada.

Viva l'españa!

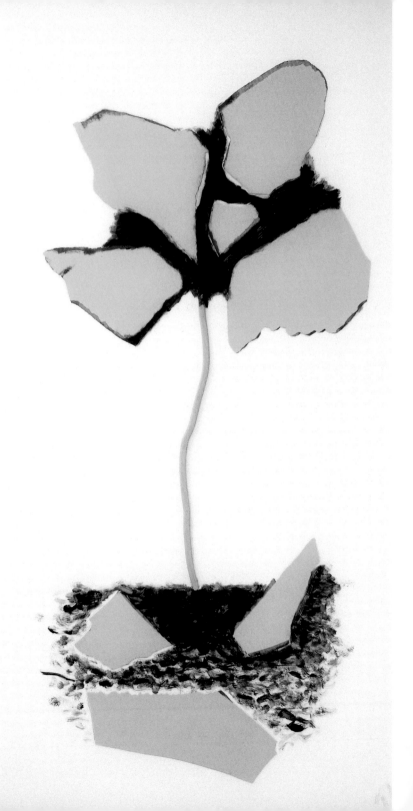

Rare Species

This unique flower was conceived and brought into existence on a summer morning in 2017.

Its thick green stem and yellow, oddly-shaped Formica petals luxuriate in the wondrous beating rays of an overhead sun.

Would William Wordsworth (the *Daffodils* man) have poured scorn upon it?

What would Charles Darwin have made of this rarity . . . its origins, and habitat?

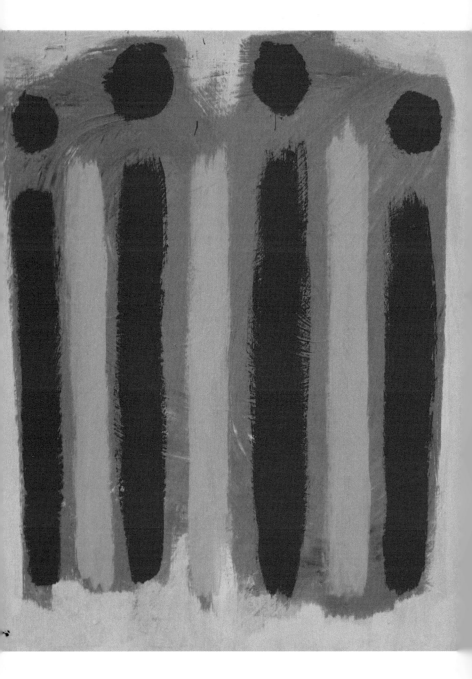

Simple Celebration

Celebration should be one of the most celebrated words in the English language. It denotes festivity, a special event, marking a particular occasion. Often it involves speeches, jokes, fun and games, music, dancing and the copious consumption of food and drink.

But for the celebration of this present quiet moment in time, four candles will suffice.

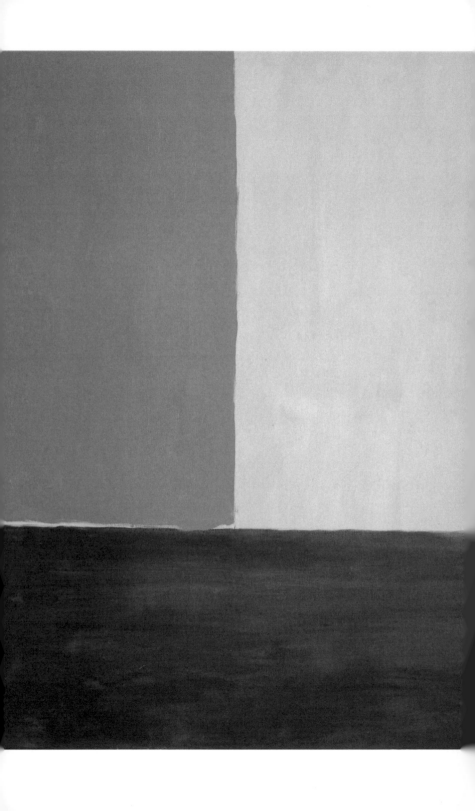

Blues

Blues are never here for long but, somehow, they usually catch up with us.

They can lead us to 'another place', or flood our thoughts with shapes, shades and shadows tumbling from blue to blue, from the palest pale, to darkest dark – a 'navy black'.

Let the brass blow . . . feel the squeal of horn and trumpet. Yeah, yeah, yeah! Get hooked for a while on blues appeal . . . and steal, steal away . . .

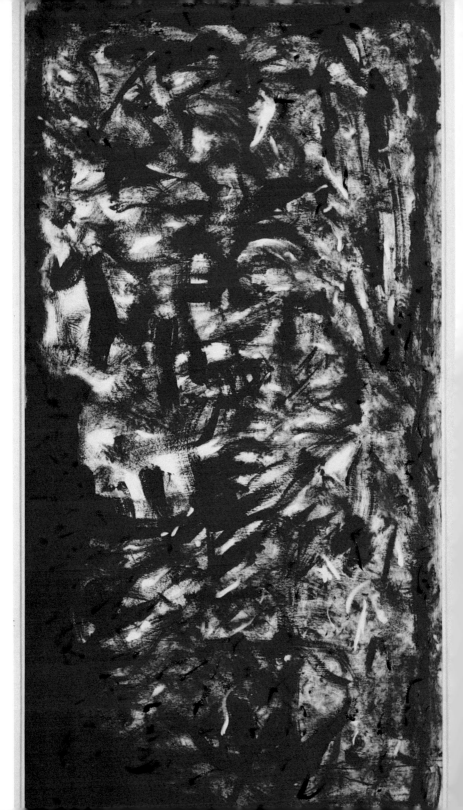

Summer-esh

Deep heat and bright light are back.
The earth red, red mixed with white,
yet, through a crack, emerges black.
Everything's loose; nothing is tight.

Gone are the pastels that danced in the sky.
Blues, greens and yellows have murmured goodbye.
Now, is the *summer-esh*, season of passion.
Little stays fresh and this is the fashion.
As rays beat down and temperatures rise,
we dance a fandango to the flash of dark eyes.
The click of the castanets, stamp of the feet
beat out the pulse of a world that's on heat!

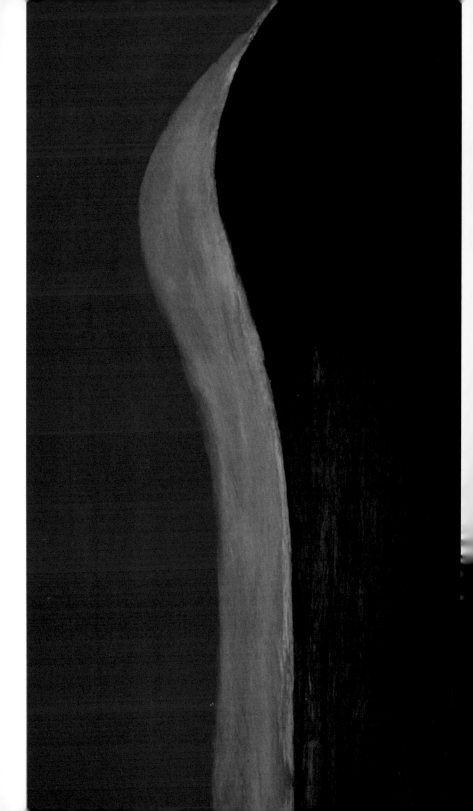

Posture

The idea is not to lean, or to bend your back:
when you stand, stand tall – it's finding the knack.
Give the face a smile, lift it, and breathe:
ensure that the diaphragm is giving a heave.

There is no need to pose, or act,
but bear in mind it is a fact
that posture shows the real you.
So stand erect and be correct.
Appraise and view yourself anew.
See a sleek and slender being,
fully charged and bubbling;
shaped for life . . . and so, so, cool!

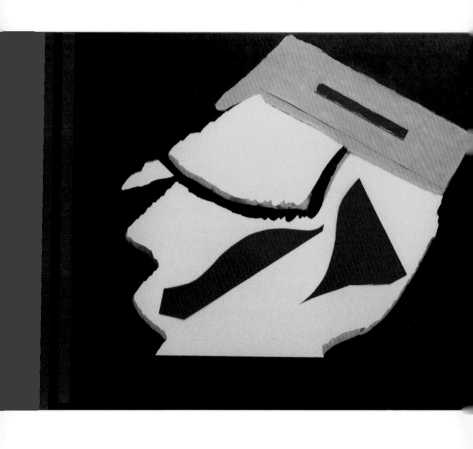

Regimental

Normal and formal
ranks and tanks, guns, bayonets and bullets,
bands and foreign lands, orders and borders,
uniforms, flags, signals and symbols,
infantry and cavalry, dress and distress,
advance and retreat,
cherish the victory, scorn the defeat!

Colours . . . gold, silver, red, black and blue.
Ring out the bells for the many and the few.
Death and dispatches, everything matches:
squares, forts and castles; unassailable walls,
battles remembered in churches and halls.

Perish the flames! The bugle is calling.
Read out the names: the last man is falling.

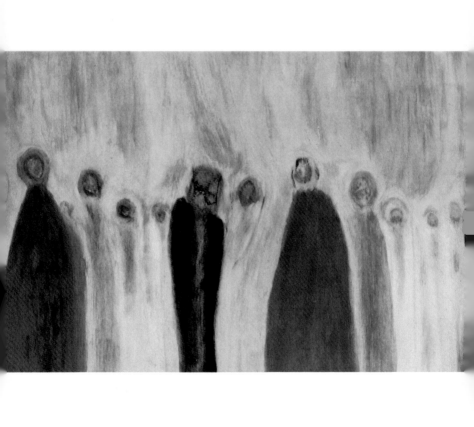

The Gathering

They had long understood. The journey across the vast desert would be a test of endurance.

In the daytime the soaring temperatures and the fierce unremitting rays of the sun seared their eyes, and as they sought out the few remaining water containers no-one spoke; parched throats would not permit it.

They concentrated, in silence, upon the steady, plodding rhythm of the camel feet.

At night, under the canopy of a blue-black sky lit by moon and stars, it was bitterly cold. They dreamed short, broken dreams; mainly about 'The Gathering', the reason for their travels.

It is here, at The Gathering, that throats are quenched, tongues are loosened, stomachs are filled, hearts are lightened, spirits are lifted and, with life, long-shadowed eyes begin to dance.

Oh! Come, gather ye! Gather ye, my people!

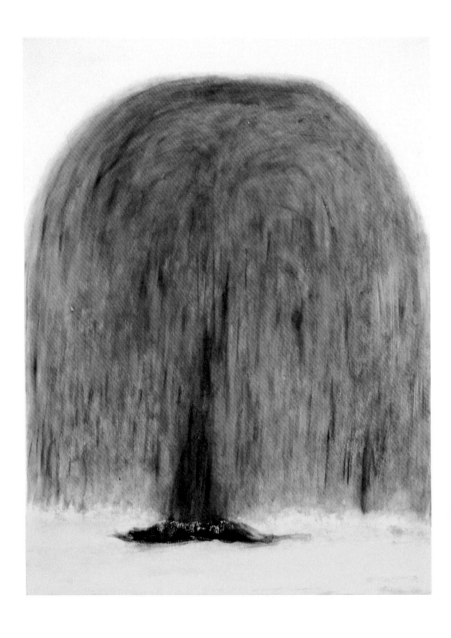

The Big Weep

Remember the willow in the garden, by the hedge.
He built a tree-house there and hung a swinging seat.
Recall the lightness, the tentative touch of early spring;
the yellowness of the fresh grown withies;
the delicate, thin, finger-like leaves
curled up toward a warming sun,
refreshed by every passing shower,
gaining fresh life, hour upon hour.

I see this tree, now densely green,
risen, huge and hanging,
stark against a sky bright blue.
Late in the growing season
there is good reason
to feel at one
with the Big Weep.

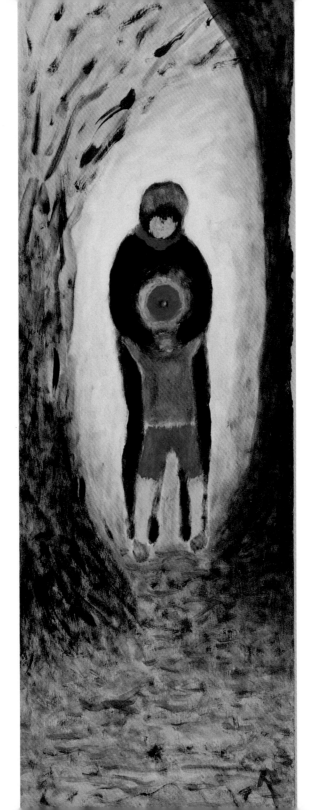

Safe

Whatever our age, we are solitary souls,
at times prone to be lost
in a dense, unfriendly, forest
where we are challenged and tested.
Assailed by unintelligible dreams,
we seem never to be rested.

Is there danger lurking between the trees?
Are there animals on the prowl?
Was that sound just the hoot of an owl?
Perhaps I should crawl upon my knees.

The narrow pathways often disappear
and there is everything to fear.
When I'm alone and insecure,
I hear the word *endure, endure.*

Will I ever feel safe again?
I, an adult, fully grown –
how do I cope with grief and pain?
How do we face the world alone?

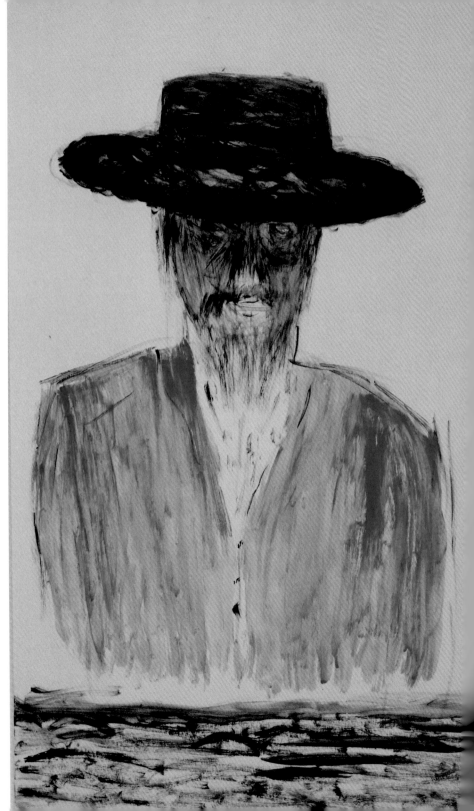

Mr. E

It is said that people enjoy a good mystery. They can be intrigued by some indication that what they see is not the full story – that there is more to a particular thing, or person.

Who then, is, this man dressed in blue and black? What is his name? Is he really Mr. E? Does he remind you of anyone? Where does he come from? How old is he? Why does he look rather sinister? Is he an actor? Could he be a comedian? He looks quite slim; perhaps he is some sort of sportsman.

Do you think that he might be an academic – a professor, maybe? Is he a lawyer, architect, teacher or doctor? Could he be a journalist, a musician or a detective?

Do you think he looks tough? Would you be at all surprised to see him with a gun?

What nationality is he? American?

. . . Could he be a spy? Where does he live? Where did he grow up?

Is he married? Is he religious? Is he a war veteran? Could he be wanted by the police?

Who this man is remains, it seems, a mystery.

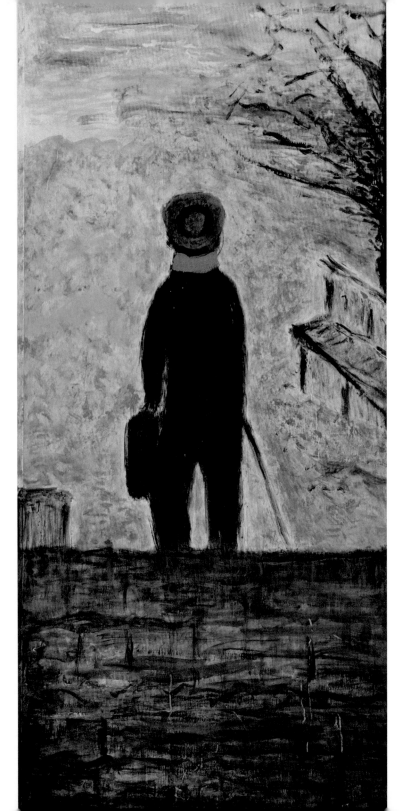

Parking

Yet again, Fred makes his way to 'The Park'. This is a grassy public space on the edge of the village. It is about the size of a football pitch and lies behind an old wall.

Just inside the wall there is a wooden bench. It is here, when the weather is kind, that Fred will sit and reflect on the many years that he has been making these afternoon walks . . . 'parking', he calls it.

Fred and his wife Mabel moved to the area when he retired. In the afternoon they had both enjoyed stretching their legs with a trip to The Park. Sadly, ten years ago, Mabel suffered a stroke and died. But Fred continues to visit The Park most days. He sits on the bench and thinks about Mabel and their life together, but he usually ends up thinking about Camilla, their only child who, after falling out with Mabel, left home at the age of sixteen and has not been in contact with her parents since.

Fred's fondest hope is that one day Camilla will end the separation. Might it be today that she will end his loneliness, share the bench with him, take his arm, walk him home and make them tea?

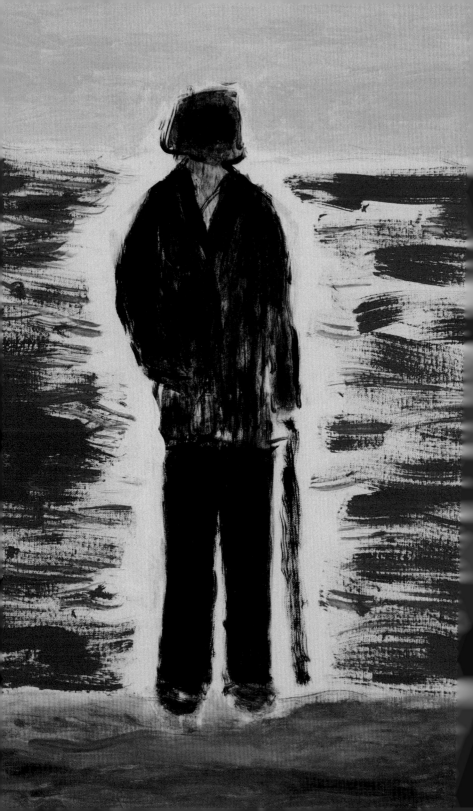

Alone

You have to fend for yourself.
You have no one sharing your life,
no close friend, partner, husband or wife.

There is just you, with your poor health,
telling yourself that you will survive,
and that it is still worth being alive.

That you, your frail self, can manage,
and that tomorrow offers consolation
and – if only – release from isolation.

Hope is the only antidote.
You have to cling to anything
that might still get the heart to sing.

Royal Ghost

I read a poem about the past
and learned that all – but matter –
does not last.

Matter, men can take as given,
but they'll manipulate its form
to make things new; by this they're driven.

And rulers rule, they play their part.
But they, governed by a life's short span,
in time depart, or just lose heart.

Kings and Queens that have ever been,
all end as dust, or callow ghosts
that figure in some coronation scene.

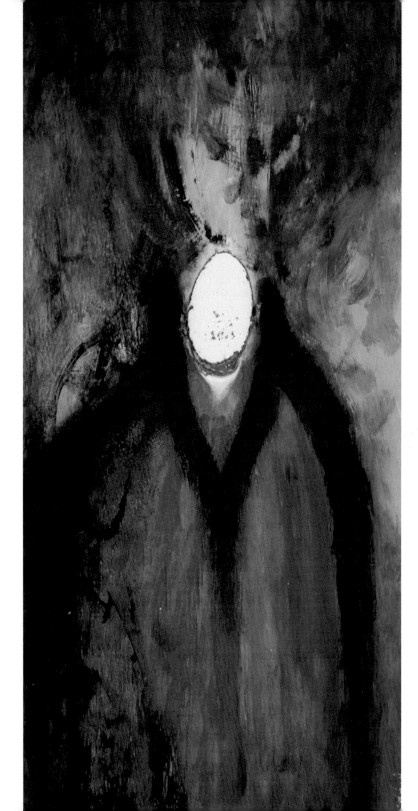

Egocentric

When people feel a lump in their throat
it is not that they are trying to swallow
the egg of a turkey or a goose.
It is more likely that they are seeking
to come to terms with their ego,
or with mortality.

Resolution

In 1915 a young sailor was posted
to serve on a British naval ship,
HMS Resolution.
It sailed into the Atlantic
and was torpedoed, blown apart,
by a German U-boat.

Sadly, the sailor did not survive.
Many of his shipmates were survivors,
left with their miscellaneous futures
to resolve.

Portal

People are portals, ever open
to the comings and goings,
to the ebb and the flow,
the quick and the slow,
of life's daily doings;

to the drug of consumption,
to the curse of corruption,
to star-spangled joy,
to love that won't cloy,
to ocean-deep sorrow,
to cares of tomorrow.

When the last of all *going* is gone
and when the *comings* are no more,
all bidding is done.
The sudden hammer falls;
the portal is closed.

Escape

I am Spanish, dark-haired, and I sport
a distinctive waxed moustache.
I welcome you to my imagined isle.
The blackness of its land matches my sombrero
and the sheer blueness of the surrounding sea
belies the fact that creatures in it
are exotic and surreal –
bright yellow crabs, two feet across,
with blood red spots and bulging eyes.
Fish, luminescent green, as big as sharks,
with stripes of black and white,
fly on fin-like wings.
They drag a heavy scale-clad tail
on which a mermaid sits and sings.
Down in the deep, numerous shoals
of small fry coalesce and simulate
great living lumps of copper ore.
Nearby, a sharp-toothed sea-dog
growls and snaps his bloody jaws.

But I cannot stay in this place.
No longer can I bear the blackness,
the sterility of the soil,
the absence of a spider or a fly.
My dalliance is done.
I must escape.

Two Ice-capades

Come join the escapades on ice.
The colours are mainly white and blue
but there are flashes of black, grey and yellow, too.

There is edginess about all this.
The music's sharp, with frequent clashes.
It slithers and slides, smashes and crashes.
Then, suddenly, it prances and dances.

Hear the beaten anvil ringing.
See the patterns slicing, dicing,
mingling, chancing on the edge
of blades and axes, swirling,
in flat fields of whiteness curling.

Hear the bleat of skis and skates,
the 'swoosh' of sledges and toboggans.
Hear the raucous shouts and laughter;
catch the echoes of a yodeller.

Feel the push, the clash, of whirling sticks,
the crunch of leaden shoes,

the presence of a Christmas jester,
a slippery seal, a princely penguin
and a frolicking polar bear.

Winter need not be a dreadful dole time,
fraught with darkness, doom and gloom.
Ice-capade, escape with an off-beat rhyme.
Let fun and joy bright every room.
Take a chance and roll the dice:
be cool, be bright, be sharp – as ice.

Let there be Light

Windows exist to let in light,
to illuminate and enlighten
dark inner space,
lending grace to all that is in sight.

Darkness yields, gives way to
solid, colourful, reality.
Neutrality has nowhere to hide;
only in light can we confide.

Dispense with curtains, flick no switch.
Behold the sun, reflect, and know,
that, it conceives the morrow,
which often brings an end to sorrow.

Oh, yes, let there be light!
Let there be light!

Unclad

I am small and unclad.
Nothing covers the cuts
and crosses that I bear.

But I am not resentful.
As I take my allotted place
in the gallery I am obliged
to show my marks.

Art is derived from the heart of humanity.
The quick and the dead survive
as witnesses to the temporariness of calamity.
And to the redundancy of fig leaves.

Art will continue to profess
that there is nothing sad, or mad,
about being unclad;
there is no cause for concern or distress,
in a simple state of undress.

Gone

Now, the upland is a sinister sea;
all dirty grey, no hint of blue,
it covers the ground where the heather used to be.
There are flecks of old burnt sienna – nothing new,
wasted, degraded ochre, no gold;
sombre, recurring streaks of funereal black.
The storm clouds gather to attack.

Without a parting kiss the summer's gone.
Gone too, the sky's mellow blueness,
all sign of scudding clouds of whiteness.
Gone are the feathery ferns so fresh and green.
There is no comfort in this season's scene.
There will be no sudden soaring lark,
no long, long day to stay approaching dark.

Gone, is the scented purple heather.
Gone, is the south wind's balmy weather.
All that was summer is now gone!
And, remorseless, winter marches on.

Judgmental?

Exercising judgement
does not involve a gym.
It has little connection
with walking, running, playing games,
or physicality of any kind.

It should not require muscular extension or contraction,
or generate perspiration.
No special dress or footwear is needed.
But the exercise of judgement is constantly practised.
In any day, at any time, we may be called upon
to weigh pros and cons, and to decide.
Decisions, simple or complex, have to be made.
Should we sit in sunlight, or in shade?
Which path to take, the narrow, or the wide?
Are there things that we should hide?

Big, and small, such choices matter.
For judgement and discernment are the key
to who we are; the self that other people see.

Rainbow Colours (Election 2017)

Do not be taken in by rainbow colours, simple sentiment-alised ciphers that have become features of an ostensibly democratic process that is widely thought to have stood the test of time.

A hundred years ago thousands of brave young men gave their lives, in France around the Somme. They fought with courage and honour. Now, when poppies bloom once more in Flanders fields, the British Government holds a parliamentary election.

In 2017 the political outlook is decidedly grey. The election is ill-conceived: it gives rise to a weak, disunited government and a parliament burdened with too many members who are either irresponsible, deceitful or incompetent. I viewed the television broadcasts from Westminster in the months leading up to the general election in December 2019 with feelings of shock, horror, disbelief and sadness. A ridiculous and loud Speaker of the House of Commons was at the centre of this shameful fiasco.

We can only hope that much-needed lessons have been learned, and that somehow, given time, the British people will choose leaders who have integrity, wisdom, appropriate experience and general competence, along with self-knowledge and belief. We can only hope, too, that the British will always remain rather cautious about new rainbows and 'yellow brick roads' (or, indeed, old red brick roads!)

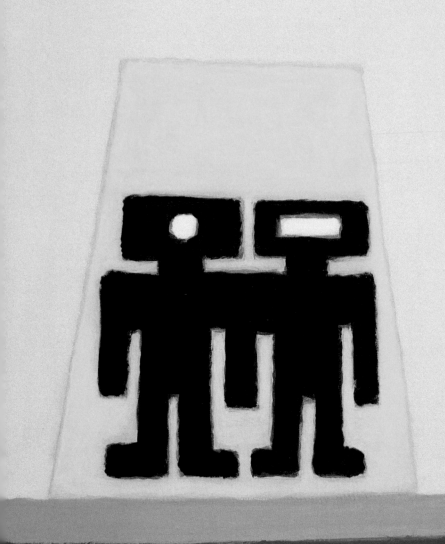

Dot-Dash

These two have met their match
and generated a whole new code
of safety which has been instrumental
in the survival
of people caught in dire straits,
often fearing for their lives.

Few would give a jot for dot alone –
a dash can pass in a flash –
but together, when all else fails,
Dot-Dash might save much later regret or remorse.

If ever you are under the lash,
remember Dot – and Dash!

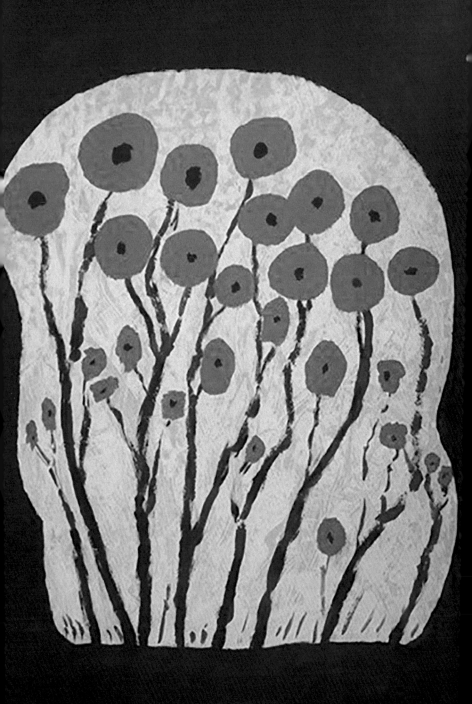

Full Flowering

Anthem to Spring

There is something special about this full flowering.
It is as though Nature's great organist
has put his foot down
and pulled out all the stops
to let the world know it's Spring –
that wonderful, perennial, mothering thing –
hopping, skipping, jumping
towards high summer.

Shades of white, blue, yellow, green,
all in glorious profusion seen,
tell us of uprisings, of downy things,
of out-flowing goodness
and the prospect of milk and honey,
of a great splurge of sunshine and showers
and of the abundant nurturing
that comes from earth's well-being.

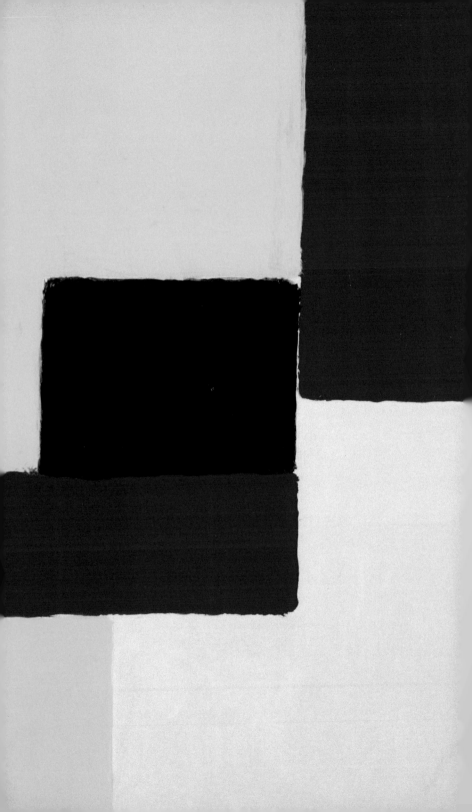

Untitled

This work is nameless,
no name's bestowed.

But everything is entitled to a calling,
even if it is . . . *Untitled*.
And it is possible to proclaim
the benefits of such a name.

Untitled is a mystery;
a dictionary will not solve it.

Perhaps the answer is, simply,
to ignore it. Consign the thing to history
and to art that is nameless
and shameless,
for there is no shame
in being without a name
or a proper title.

But if I were to grasp the nettle
I might acknowledge the fourfold tone
And make the label *Quadra-phone*.

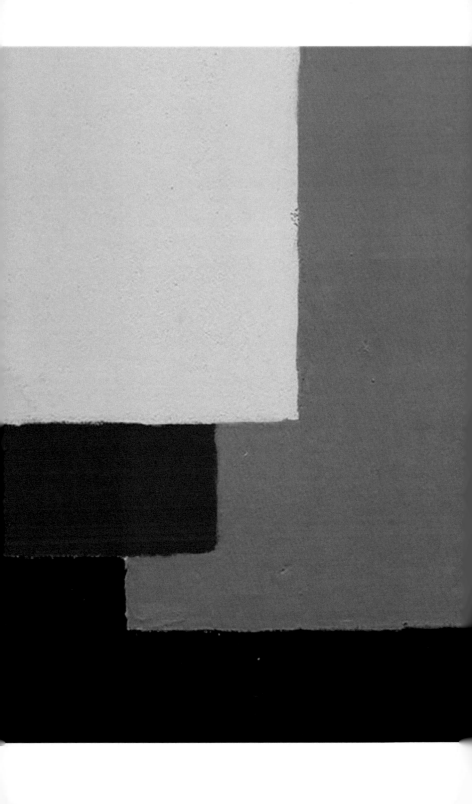

Poems at an Exhibition

The exhibition building is predominantly white.
It comprises four light and spacious rooms.
On the blank walls visitors are invited,
in their imagination, to view the poems,
read by a small team of performers,
to the accompaniment of modern jazz piano music –
Keith Jarrett's *Cologne Concert*.

The cover of the book, of the same title,
is in four strong, vibrant colours –
black, red, orange, and sky-blue;
the form . . . four rectangular blocks,
different, modern, clean-cut.
It contains a warm invitation
to dip into modern poetry and jazz.

Go for it!
You will not get lost.
The four rooms are named . . .
Over the Rainbow
This is Not a Yellow Brick Road
Recollections and Reflections
and *Anything Goes.*

Harvest Time

Here in the land of your fathers
plough the fields, repair the drains,
scatter the good seeds.
Cut back the hedgerows, control the weeds.
Let weather, rain or shine, play its part;
sustain the land's demanding heart.
Lightning, thunder – aid the wonder
of the growing, ripening grain.

As summer heat sounds its retreat,
approaching autumn, cloaked in gold,
attests to the fertility of earth's warm bed.
But before all harvest leaves are shed
there is a story to be told.
Soon, soon, the waiting blade and wheel
will turn, and bring another harvest home.

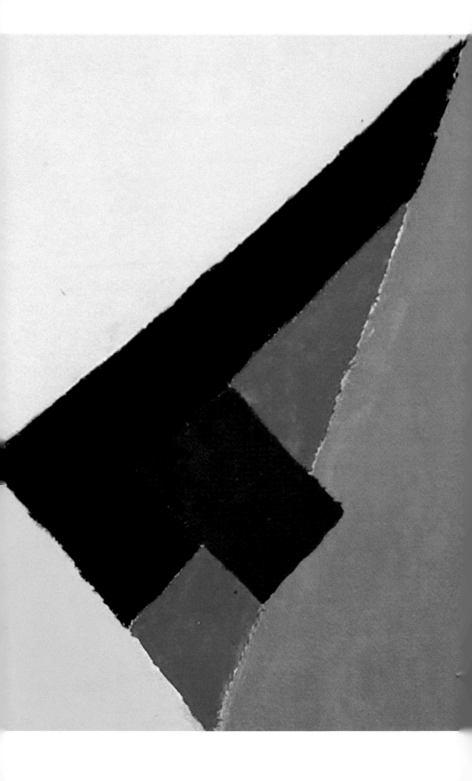

Right Angle

Right angles feature
in many projects and constructs.
Other angles are usually left out.
They do not fit.

But in a straightforward (logical?) way,
if a right angle becomes attached to a left angle,
the two ninety-degree angles
will produce a straight line.

There is not, necessarily, any connection here
with *straight talk*, and often
it is difficult to know if an angle is right –
or is totally wrong.

Whatever you decide,
no matter which way you turn,
the right angle is a useful concept.
It is usually important to see things
from the right angle –
and this should make it easier
to engage in *straight talk*.

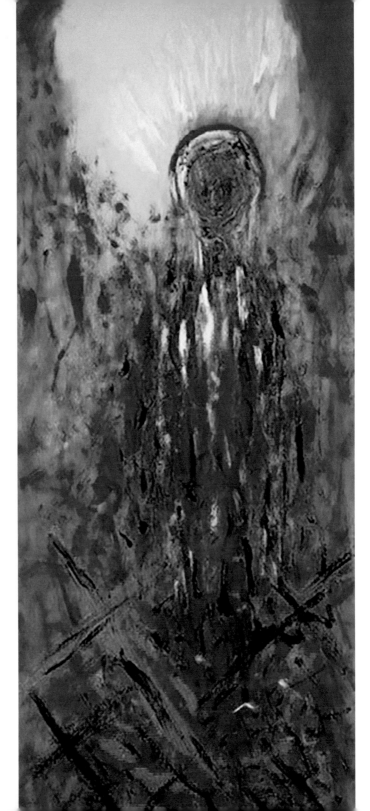

Joan

Monday 15th April 2019 . . . headline news:
in Paris the cathedral of *Notre Dame* is on fire.
The spire is gone, the roof is lost.
Two towers still stand.
France counts the cost.

But history cannot be destroyed
by flames, death and destruction.
Revolutions, emperors, kings, queens,
births, deaths, all manner of events
will be recorded somewhere, somehow,
and remembered, somehow,
by someone in future time.

Fire cannot kill faith.
The flames which, at the stake,
took Joan, the Maid of Orleans,
were more lethal than those
now devouring Notre Dame.
The stone towers might no longer
cast shadows by the river Seine,
but the steadfast faith of saintly Joan,
the legacy of her mortal pain,
will always mean more
than a fleeting drama
watched by fearful, faithless, millions
on flickering slick silver screens.

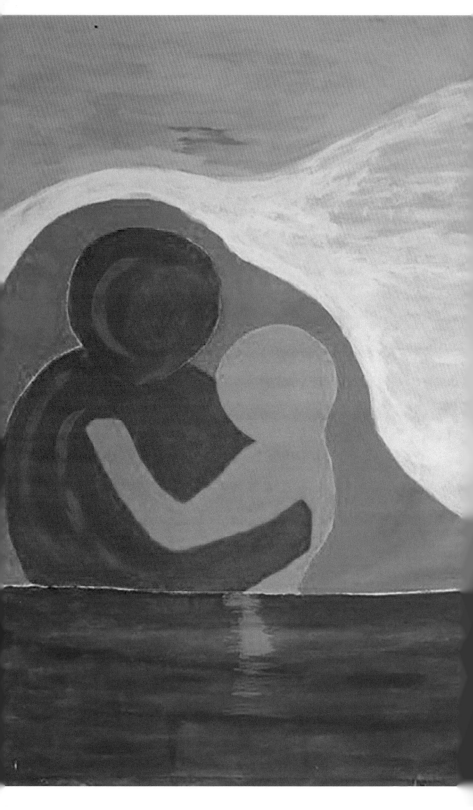

Morning

It is always morning when a child is born.
From the darkness, the little one comes,
to breathe beginning's first breath.
Somewhere an angel blows a horn.
The sky opens its eyes.
The sun shines. The mother sighs.
She holds her treasure close.

Day breaks on a virgin world.
Each new day begins with morning.

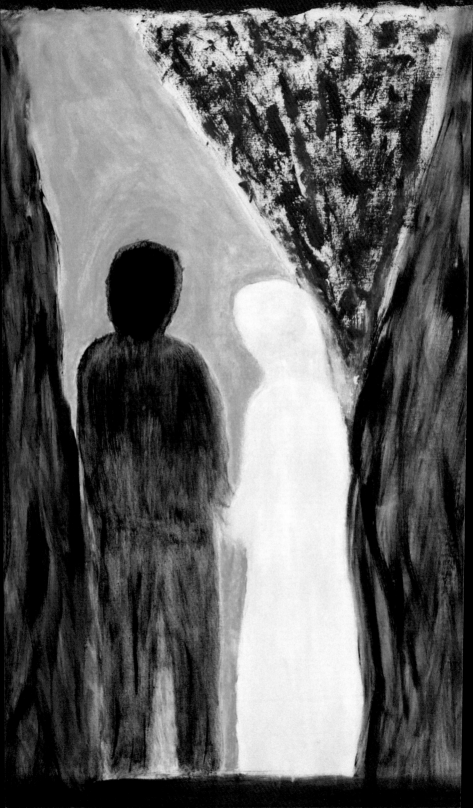

The Undertaking

Two newly-weds look out
onto the world in which they will be
as one, together.
The Undertaking underwrites
and enshrines their future.

The pace they set together will be steady;
no need for over-taking or over-reaching.
With grace, in lasting love and harmony,
together, they seek to live fulfilling lives.

There is no greater undertaking.

Portal 2

Through this portal comes
each mysterious new being
faced, uniquely, with a mortal life
of unknowable duration.
They know not who
will be their companion, husband or wife,
nor what might be their occupation.

A life is not foretellable.
It is a singular adventure;
a journey to make, a mountain to climb.
There will be rivers to cross,
loss to bear, troubles to face . . .
a sudden void, an empty space.

Each life will see both joy and pleasure,
pain and sadness. So, looking forward,
set the compass, meet life's measure
and tread the chosen path with gladness.

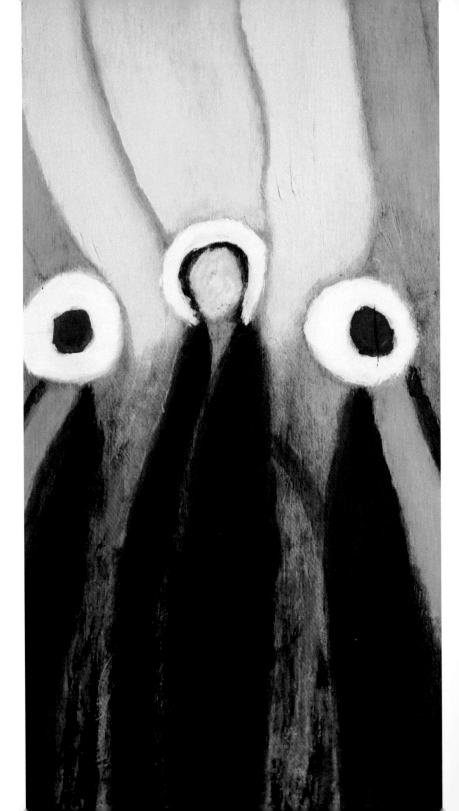

Sisters

Sisters of mercy, grace and love:
what is the message from above?

The simple message is quite clear –
do not be daunted, face your fear.
Be patient, have faith, hold firm.
See the apple, ignore the worm.

The light burns bright as they proceed
to intervene and intercede
for those who dwell in different places,
and walk in crucifying shadows.

Brightly, brightly, shine the haloes
on all the sad, tormented faces.

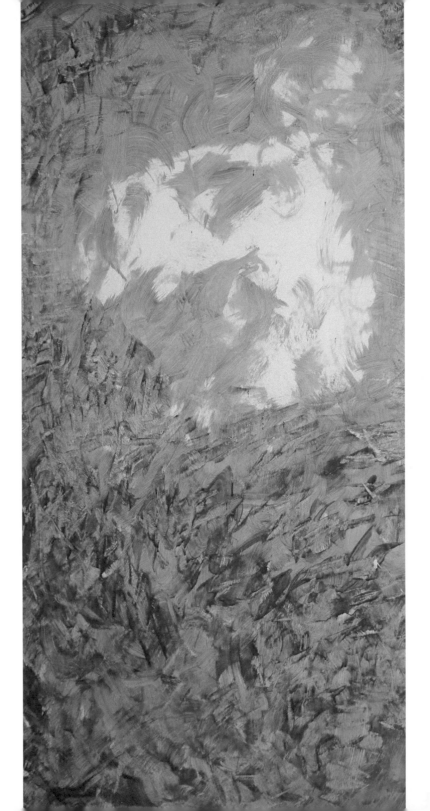

Light Blue

Light blue, the colour of eternity,
the matrix of modernity.
This blue is cool yet warm;
it rings so true.

See how it embraces
pale, lonely white,
befriending and inviting
it to dance a jig, or play
 at kiss and tell.

If this blue should show its hand
and cast a spell,
bewildered white
might slip away to left or right,
or seek the cover of the night.

Against the dark, light blue will spin
its fairy tales across the sky;
they'll tell how life is not a prize to win,
but an adventure to enjoy.

Each day the sun awakes, to rise
and through that blue
shed light on you.

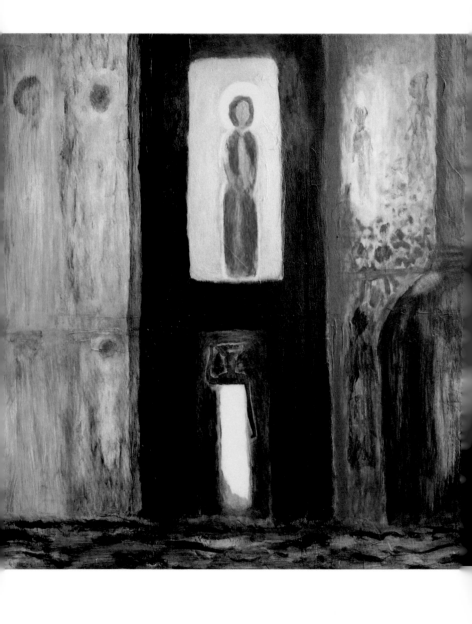

Eastern Promise

The first shy wink of each new dawn
reminds the waiting world that it exists,
that people's lives will carry on . . .
A haloed morning sun insists,
'Get up, get on, and get things done!'

So, shepherds watch, and wise men rise
to follow a heavenly guiding star.
Westward they travel from afar,
pay homage to a new-born king
and call a waiting world to sing
as jubilation fills the skies.

Through time, more men, not all so wise,
will hear the call to glorify the Lord of All,
but – not content with what has been –
they change that *oriental* scene.

Work by hand and brain is hallowed then;
great revolutions set in train,
which reach the lands of the rising sun . . .
another era has begun.

Eastern promise stands bold and proud
on ancient walls and mounds for all to see,
but a future sparkling with IT
is waiting, to be saved within The Cloud.

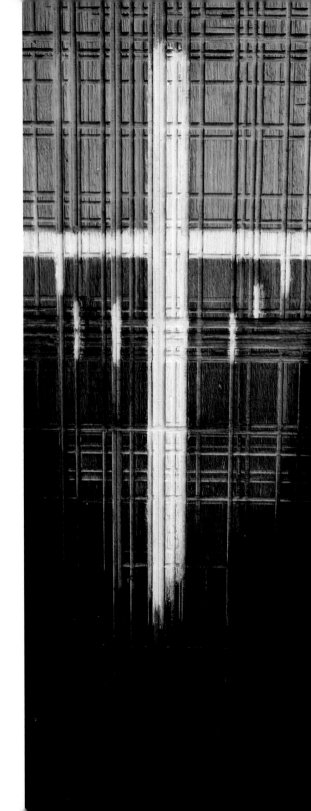

A Cross

Two intersecting parts will form a cross.
A cross can indicate consent
or mean an asset's fully spent.
A cross is drawn upon the heart
in affirmation of a truth.

A cross is used to send a kiss,
or take the place of something missing.
But, most of all, it is the sign which says
that Jesus lives –
that he the troubled world forgives.

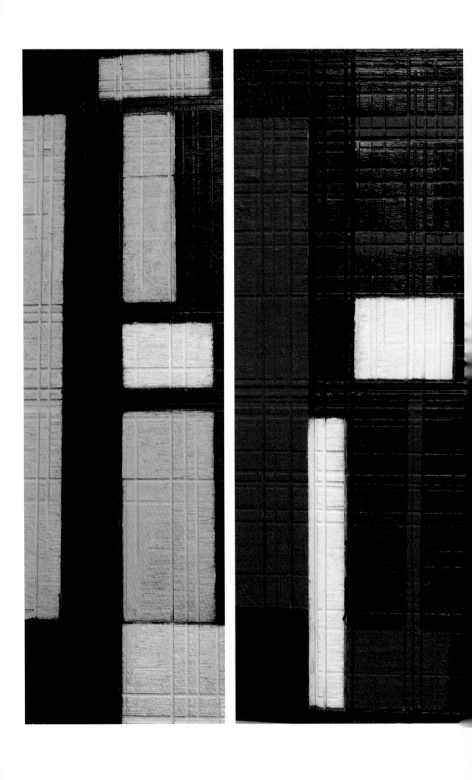

Highlights 1 & 2

The focus is on two tall straight-line buildings
girded by unobtrusive steel.
Against the sky they appear black,
like cardboard boxes standing on end,
with holes that are square or rectangular
appearing at regular intervals.
These are the 'highs' – the big boys
on the block and in the street.

But the big attraction is the light,
which floods from architectural surfaces.
See the purple, pent with passion
in this urban-resurrection site,
bursting from the new-built blade
of steel, cement and chiselled stone.

Cool lime comes as a hint of spring,
cheering, perhaps, the taxi driver
with a fare looking for a fling.
In his hand he holds a fiver.
One hail can make the meter ring.

These highlights speak to the best of life . . .
of love and laughter, peace, goodwill.
When night's asleep, and all still,
there is no raucous, noisy strife,
no hint of alarms lying over the hill,
and no-one spoiling for a fight
in this arresting resurrected site.

In the Deep

Down in the depths of the deep, deep sea,
lie mysteries to be solved.
Curious fish swim, unfettered, free,
and unaware of we who have evolved
to be corralled in urban ranches,
towers that seek to touch the sky
and soar above all tree-top branches.

Our life's complex, and devilled by doubt,
The questions abound; what is the plan?
Is it this, or is it that? Are we in, or, are we out?

What, oh what, is our true state?
What, oh what, will be our fate?

Diverted, perhaps possessed,
by screens, and anything
which fails to tell us what life means,
we live in a world that's just so . . .
so terrible, so wonderful, so ugly, so beautiful,
so sleepless, yet so vital, so awake.

"So vital" is the reason why
the world will always find a song to sing,
and never, never die.
Its song of dreams will keep on echoing
in serenade to earth and sky.

Down in the deep the life is simple.
The mantra is . . . breathe, breathe, use gills and fins,
show off your scales and prey, and prey –
seek out fresh sustenance each day.
No need to worry about sins.
Amongst the debris on the sea bed
there will be a place where you can mate
and raise your offspring as you will,
free from politics, blue or red.

Perhaps you will join with others
to form a mass performance shoal,
a band of revolutionary brothers
who pursue, with you, an unnatural goal
determinedly: to dodge a Darwinian fate
in a relentless evolution mill.

The Prize

Here it is, the book appraised,
now prized, by wealthy donors.
It is open, displayed for all to see
in regal colours, red and gold,
on literature's familiar base,
an inviting shade of pure and simple
unpretentious white.

But, why the lack of black,
the stuff of words upon the page?
Black provides the lasting impression.
It tells the author's tale.

Threads of history are woven in black,
in black on white, a people's past preserved
but rarely is *that* colour prized.
Is, perhaps, redress deserved?

Alignment

Dark-brown hessian in a square frame
(once a noticeboard).
A smaller block superimposed – black –
in studied alignment.

From a merchant's yard,
thin strips of soft wood used as packing,
straight of edge, contrasting in colour and texture,
yelling for inclusion in the alignment,
now appear as parallel constructs,
 at measured distance.

Crossings, of line or purpose, are ruled out of order.
All is placed with precision, respect and thought.

Alignment involves seeing what is happening,
taking place, in a given line,
or in a new-found space –
then acting, allying, not denying;
posturing with a different face?

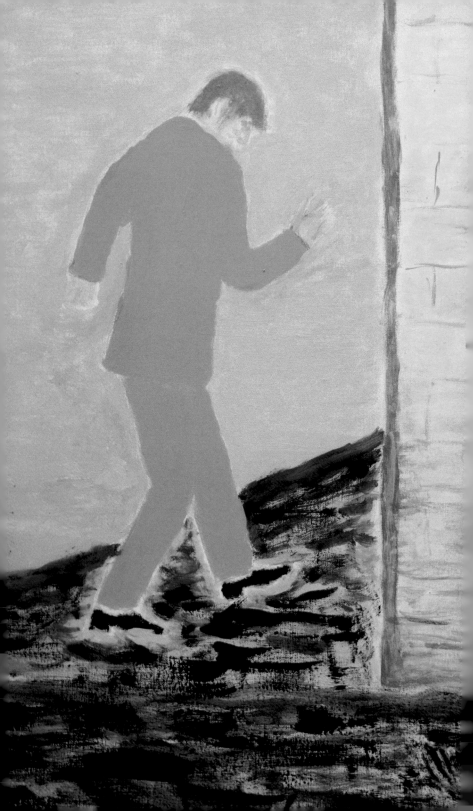

Now, Straight Ahead!

It isn't easy to be street-wise.
Any country lad might wear a frown
when visiting a city or a town.
That Fred seems lost is no surprise.

The busy roads and streets all look the same;
many of them, it seems, don't have a name.
The numbers are confusing and out of sync.
Traffic lights change before you can blink.

But young Fred's memory proves good.
He remembers what the man said:
At the corner, go straight ahead.
Message received and understood.

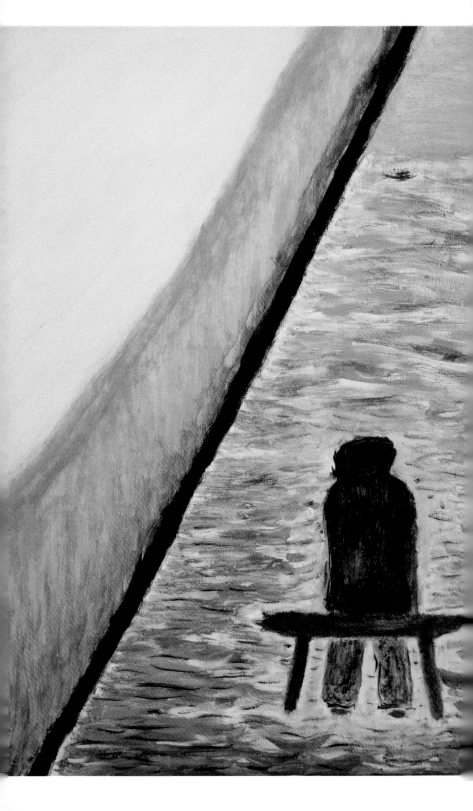

Rural Retreat

This rural retreat, his country seat,
is a simple bench
where the heart's beat slows,
fists unclench
and there is a tingle in the toes.

Here, far from the blight of urban grime,
from constant noise
and petty crime,
the air is fresh, the scent sublime.
In this, his very special place,
he looks and listens to passing time.

Trees, birds and insects command his gaze,
cause him to marvel at the ways
these creatures live and spend their days.
It seems that, to them, life itself is quite enough.
Once they have found some warmth
and got wherewith to feed
they have no great desire,
no overwhelming drive,
to gather stuff that they do not need.

May all those alone, advanced in years,
observe the insects, trees and birds,
take heed, relax –
enjoy a special country seat,
in the lasting peace of their retreat.

Five

Count your fingers and your toes.
The sum should be just two times five
(or five times two).
Five fingers fit each glove you wear,
five toes fit in each shoe.

Five consists of one plus four:
with nought plus five, it's as before.

Five times four will give us twenty –
a score and nothing more.
On a dartboard it's the top,
whilst in the middle it's the bull
at five times ten . . . a solid fifty.
If you drop short, that's not so nifty,
you'll bag a meagre five and twenty.

Full circle comes at three-six-o.
Add five to make a year or so.

Let five stones fill a child's hand.
Let five musicians form a band.
Remember five is a half of ten:
that's when a decade starts again.

If 'fives' are out for just a while
count the stones, the fingers on one hand,
roll back the years,
pick up the darts that did not land,
then do a check on one foot's toes
and smile at the magic in a bunch of fives.

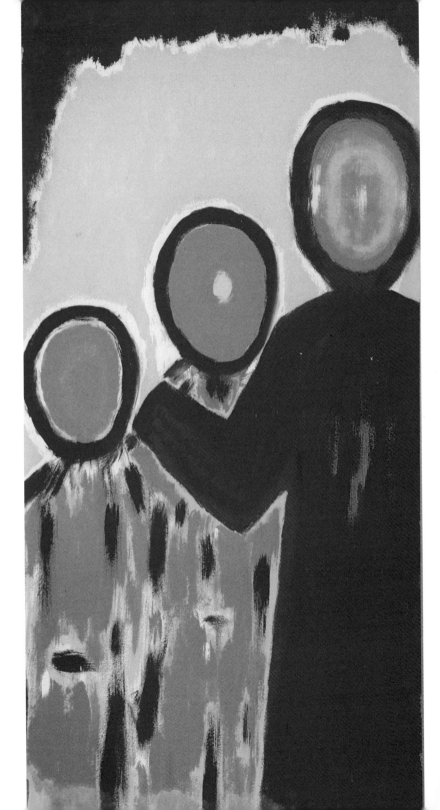

Hope

What do they see, these three figures
staring out from this Earth, this ever-turning globe?
Do they see some shrouded infinite mystery?
What shows on the faces of those gazing into space?
Might they see something that time has decided to conceal?

Is there a future that can be?
Does hope spring up eternally?
Does hope sum up what lies
in wait for us beyond the blueness of the skies?

To all who come and all who go,
will hope deliver eternal grace?
Will hope shine bright on every face
that turns towards the celestial sun
and its life-giving, constant show?

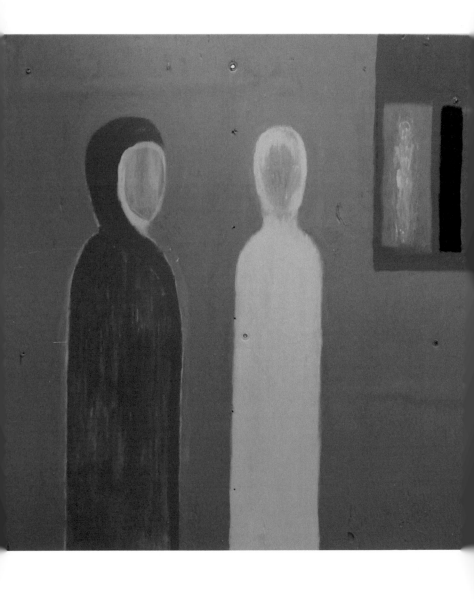

No Questions, Please

No questions, please:
it's answers that I need
to questions that assail my brain.

Should I buy a plant, or sow a seed?
When I've decided where to go,
should I take the bus, or catch a train?
(I'd like to walk, but it's too slow).

What I'd like is an Answering Machine
to answer any question asked . . .
what meat to buy for lunch today
(I much prefer it fairly lean),
and is there, please, a different way
to keep the kitchen sparkling clean?
Who *was* it came to visit yesterday?

Yes, I'm flummoxed when I'm asked a question,
afraid I'll answer incorrectly –
not so good for my digestion.

But may I ask you quite directly:
where *can* I find an Answering Machine?

Blue Bamboo

Once, green carnations were the rage.

So we'll re-invent the orangey, yellow, green bamboo –
turn it into a stunning blue –
and think of it as heaven-sent.

It's true that pandas and monkeys
might be foxed by such a change
But, for all we know, their colour range
might fail to register the blue;
they may still see the old bamboo.

I'm told that it takes more than a change
in colour code to kid the pandas and their kin.
If blue bamboo's not far away,
they will travel fast through jungle, thick and thin,
to chomp on what they see to be bamboo;
blue bamboo that's heaven sent.

Geo Matter

From earth, the sky above is blue,
with clouds of white or grey.
Geography confirms that this is true.
But sometimes when the gods, like Thor,
have cause to frown, clouds can be black.

And should the skies be subject to attack
by aliens from outer space, testing products
of some post-nuclear-war-game-paint-ball place,
earthlings, in fear of global warming,
might raise their heads to see
a sky that's bloody beetroot red,
and read the runes which say . . .
the mighty sun is dead.

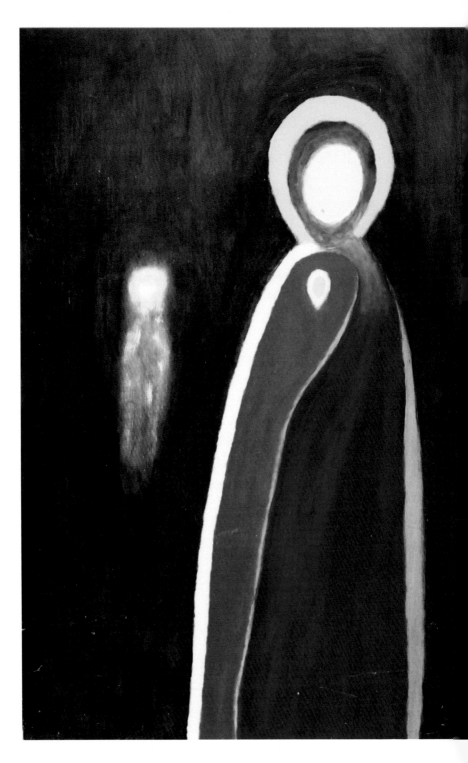

Mary

Many, many Marys, this earth has known.
Few of them walked alone for long:
they grew up fast.
They did not seek a life of ease.
They cast around for jobs to do,
for someone else to please.

These Marys needed most to serve,
to be of use, to make a difference
to another's life.
Often, they became a wife.

Biblical Marys, four it's said,
(Magdalen was not the only one)
all share a starring role
as daughter, maid, wife and mother.

One Mary stands above all other;
the son that she bore
still refuses to be dead.

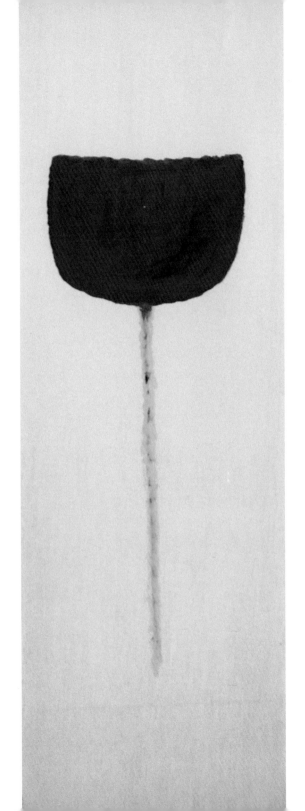

Deep Cup

A singular deep cup comes
to everyone at birth.
This unique bowl,
a worthy vessel from the start,
stems from double helix DNA,
spun out through time, midst myriad stars,
beyond the familiar Milky Way.

At times this sacred cup o'erflows
with life's own luxurious, libation,
to boost the bravely beating heart –
and seeds of 'Magic Moments' sows.

A mindful secret garden grows;
a cornucopia without measure,
a source of happiness and pleasure –
your own deep cup,
your lasting treasure.

I, a Pilgrim . . .

You have seen the paintings
and read the words
which were engendered
when I journeyed through a dark, dark zone,
where I was visited by fierce flocks
of scary birds, all squawking,
squawking . . . 'Alone, alone'.

But then I, a pilgrim,
met new friends with smiling faces,
they cried warm tears, they sang their hymn
and echoes reached to far-off places.

No longer do I labour night and day
But still I walk, following my feet,
to the call and the beat of the pilgrim hymn,
toward the end of a pilgrim's way.

AND SO IT GOES

– still the Rose of Memory grows . . .

The 'Ninth Years'

Looking back and moving forward

So far I have lived in ten historical decades, beginning with the 1930s, and the ninth year of each of those decades has been exceptionally eventful in my life, if not also in the world at large.

The first of these 'ninth years' was **1939**, when I was six years old and attending All Saints' School in Osborne Street, Newton Abbot. In that year my country went to war against Germany for the second time in less than three decades, and I can remember well my dear grandmother's tears. Then came the warnings, the regulations, the restrictions, the evacuations, the sirens, the bombings, the deaths and the devastation. Eventually in 1945 there was victory (of a sort), release and relief.

The poem which follows was written in 2004 for an old school friend, and harks back to those days:

Osborne Street

Osborne Street, where we were born
some seventy years ago,
knew the fortunes and the feet
of those who shared that time and place.
The Steers, Smales, Tantons, Smiths,
Furzes, Heywards, Crispins, Prouts,
Bowdens, Darbys, Cliffords, Grubbs,

Reynolds, Roberts, Selleys, Banks
and Barbara Biggs, with Mrs French
at 17, across the road
from Hatherleys and Trimms.

No saints lived there,
none 'holier than thou'.
They worked and gardened
– some more, some less –
played their little games,
laughed and cried,
made out, somehow,
between the shouting-matches,
squabbles and long-lived lies
until, often taken by surprise,
they died, retired to the small front-room,
blinds drawn.

In the park, the rocking see-saw stands
jammed, jacked-up by boys we knew.
Swings on chains creaked and groaned
as way above the bar we flew.

We chased the heavy metal
cold, clanking grips
of the maypole roundabout,
warmed, sometimes,
by the hands of girls,
who whirled in dreams
to futures seen in playground trips.

The football pitch was covered goal to goal
with power station fodder for the Grid.
We climbed the stacks and down we slid,
tobogganing on frost-free coal.

And on the corner with Quay Road
Black Jack shoves hundredweights in sacks,
makes up his loads of 'nutty-slack'
for those who push their prams to bring
their hearth and stove's small ration home,
in air that's rich with barley roast –
the smell of baker's-cart warm yeast,
mixed in with horse dung steamy-fresh
and railway smoke that's drifting east.

Whilst up the street in Hugh Mills' yard,
beyond the fortress gates and jagged glass,
midst bricks and pipes and blackberries,
scrawny labourers graft for brass
to buy their bread and beefy lard
and feed the kids and wives, who wait
to celebrate each Friday night.
There's no security –
except the work they cannot shirk.
And, in the end, the cemetery.

Across the street stands All Saints School,
a limestone fortress, strong indeed,
with massive door, enormous key
and windows so we cannot see

distractions, other than the sky,
as we learn each golden rule.

Here Christian mentors, Taylor, L. and Cannon, C,
mould the likes of you and me,
teach us to sing the hallowed hymns –
'For All The Saints' we know so well

and 'All People That On Earth do Dwell'.
We hear the timeless tales they tell,
we do PT; there are no gyms.

And so we reach our watershed.
Small feet, with care and love well-led
toward a future full and kind;
fond memories that stay
to warm the heart and still the mind.

And I am glad that my small feet
grew up to walk the world
from Osborne Street.

1949 was my last full year at Newton Abbot Grammar
School. I duly received my School Certificate of
Matriculation from London University before passing
Civil Service exams and starting work, early in 1950, at
HM Customs & Excise in London. I found lodgings in a
hostel near Earl's Court.

By **1959** I had been a tax officer in the Inland Revenue and an SAC in the RAF (during my National Service) before becoming a tax specialist with Barclays Bank in Exeter. This was the year in which Joy and I had a holiday together in July and married in September.

In **1969** Wilson and his Labour government were in power – and I was a student! Back in 1960 Joy and I had bought our first house. I had gained qualifications in banking and taxation, worked as a supervisor in London and been assistant manager at the Income Tax branch of Barclays in Guildford.

However, in the summer of 1968 I had resigned from the bank and was an undergraduate at the University of Exeter, studying Economic & Social History. This was the beginning of an amazing three years of higher education which fundamentally changed my view of the world, especially in relation to political, social and economic matters. At this time we lived in a small semi-detached house in Exwick on the outskirts of Exeter. The two poems which follow reflect my thoughts and feelings around the time I went to university.

Where Are the Hills?

Where are the hills and mountains to be climbed,
the lakes and rivers to be crossed?
Are there no forests heavy with the scent of pine?
Where are the knights with whom to fight?
Where are the tigers burning bright?
Where the day which gathers up unsleeping night?
Where the torch? And where the light?

With Open Minds and Colours True

With open minds and colours true,
military and business men
– now students of mature years –
together seek horizons new.

They climb the fabled knowledge tree,
view every possibility;
from every angle view each clue,
that might suggest an horizon new –
these folk with open minds,
and colours true.

They boldly walk the pilgrim's way
and meet elation and dismay.
With eyes that never seem to tire,
other men's wisdom they acquire.
There's time for work, not much for play,
in each self-searching, cloistered day.

When **1979** arrived I had gained experience as a field researcher in Agricultural Economics (a job I took during the university holiday), graduated in Economic and Social History, and been a lecturer in Business Studies at East Devon College for about four years, before being appointed Head of Banking Studies at Exeter College in January 1975. Thereafter, as a fellow of the Chartered Institute of Bankers,

and founder member of the Association of Banking Teachers, I became involved in educational developments intended to meet the requirements of a rapidly changing industry.

From Christmas 1971 we lived in a house called Glenthorne in Searle Street in Crediton. Our children thoroughly enjoyed the space provided in this large Victorian semi-detached house; they also found little, if any, difficulty in adapting to their new schools.

Ten years later, early in 1981, we purchased a large dilapidated country property called Gunstone House in Neopardy, near Crediton.

After renovation, Gunstone was the venue for our elder daughter's unforgettable wedding reception. Over the ensuing years this proved to the first of a whole series of similar 'magic moment' wedding occasions.

In 1986, after many family visits to The Mare and Foal at Yeoford and after celebrating our silver wedding anniversary, we sold Gunstone – with some regrets – and moved for a couple of years into a small terraced house in Exeter. At around the same time we acquired a building plot at the top of Redhills, and in April 1988 we moved into the brand-new home we had had built there, which we named Crisping House.

In late 1987 I was invited to give a series of lectures at the Polytechnic of Hong Kong. We managed to include in this visit a very educational trip to Canton in southern China.

In **1989**, with the next decade now imminent, we decided to do some holidaying in Central Europe, and in the next year we enjoyed a lakeside holiday in Brno, Czechoslovakia. Here we met delightful new friends, Jarka and Jana, with whom we have since shared many holiday experiences.

However, there was soon to be a major change in our lives. In December 1993 I retired from my job at Exeter College and by **1999** we had sold Crisping House and moved to a house called Buckland at 39a Polsloe Road in Exeter. Our next project was to build a studio workshop in the garden of 39a, and on completion this was known for a time in the family as 'The Great Hall'!

After I retired, I combined some property projects with much reading, writing and performing poetry, artwork and music, especially choral singing. I sang with many different local choirs, mainly the University Choral Society, and became a regular attender of the Dartington International Summer School (DISS).

On one of these occasions we were joined by Richard and his family. We like to think that this brief 'Dartington experience' contributed to their ongoing interest in, and enjoyment of, music.

Whilst attending DISS in 2008 we stayed at a delightful place called Northwood, which is beside the river Dart in Buckfast. The poem which follows is one I wrote at that time.

At Northwood

This quiet place
is loud
with sounds
of yesterday:

the clunking wheels
of the old hay-cart;
the lusty folksong learnt by heart;
the silver band's *How Great Thou Art*;

garden overtures
with tarts and cream;
the hiss of traction-engine steam;
Shire horses
plodding in a team,
show-dressed,
in glinting, clinking brasses;

sea-sounding salmon,
stretched, lured and fetched
to whispering Dart-side grasses;
flat-capped youths
and cotton-frocked lasses.

An old farm-hand
is heard to say,
'I be g'wain to 'ave me tae –
they boo'ful scones done Dev'nsher way,'

and a child at play
says 'What'ee do that fur, Granfer?'

This quiet place
is loud
with sounds
of yesterday.

The Dartington International Summer School had an effect upon me which was similar to that of my university years. It broadened and deepened my interest in, and enjoyment of, music, literature, art and history. I met and performed with many talented and friendly people. For many years it was an experience to which I looked forward every summer.

Highlights included a concert which was a special anniversary repeat of a Beethoven concert which had first taken place in the early 19th century. The programme included both his 5th and 9th symphonies and one of his piano concertos. It started at about five o'clock in the afternoon and concluded (after two intervals!) with fireworks at about eleven o'clock at night.

On numerous occasions I was either in the audience or taking part in performances of music by Handel, Dvořák, Mozart, Verdi, Rachmaninov, Tchaikovsky and Strauss, and on one very memorable occasion enjoyed a performance of Janáček's *Gagolithic Mass* in Saint Andrew's Church, Plymouth.

At DISS there was always a wide selection of courses and workshops from which to choose. In 2015 I joined a folk music course led by Kathryn Tickell. It was here that I met a pianist called Tom Arnold. At the time he was a student at the university of Exeter and he later accompanied me in a performance of my poem *O, Devon, Devon!* (which is written to the music of the traditional Swedish melody used for the hymn, *How Great Thou Art*).

O, Devon, Devon!

O, Devon, Devon, you are our birth, our rest place;
You are our home, no matter where we've been.
You are by far the dearest and the best place
And we hold dear each Devon name and scene.

Refrain: We sing our song, O county fair, to thee,
You lift our hearts, you lift our hearts.
We sing our song, O county fair to thee,
You lift our hearts, you lift our hearts.

You are our path, you are our hill up yonder,
You are our bed of limestone, granite, clay.
You are our moors of heather-covered splendour;
Our rich red land, all patched with green and grey.

Refrain: We sing our song . . .

O, Devon, Devon, you are our book, our history
Of farming, mining, weaving, breaking stone;
Of hounds and sea-dogs, and of Christie mystery –
How blessed we are, to count your land our own!

Refrain: We sing our song . . .

In the same week as the folk music course I also worked
with the poet Alice Oswald, who presented and led a very
interesting course focusing upon the work of the
fourteenth century poet, Geoffrey Chaucer. This next
poem is one which I wrote at that time:

Portrait of a Pilgrim Dancer

Against a background of studio blackness
a slender woman prepares to dance.
She is stretching her hands, fingers,
arms, legs, neck and back,
and bending forward,
almost kissing
her silver-sequinned dancing shoes.

This actress and dancer
is no Wife of Bath, no Prioress,
but in time she could consort
with Shipman, Scholar, Doctor, Knight,
Reeve, Squire, Miller, Monk;
tell a tale of princely court
or the seedy side of some seaport.

Her dress of silky cloth
is alive with summer flowers –
red, yellow, blue, pale pink,
purple, mauve –
drawn from fabled hills and bowers,
members of her parliament,
and symbols of her heart's intent.

Her dance will show all pilgrims how
to welcome summer with its *sonne softe* –
to laud and praise each branch and bough,
to tap their feet, let rhythms flow –
and raise their arms *alofte*!

Often, there were excellent jazz sessions available at Dartington, mostly organised and led by Herbie Flowers. I was fortunate to secure a place on a course run by Jackie Dankworth, the daughter of Johnny Dankworth and Cleo Laine. We studied and performed Duke Ellington's *Mass in Blue*.

Jazz Rehearsal

Jazz is usually energetic,
loud and exuberant.
Notes are pinched, pulled, stretched and squeezed.
They may be rough or smooth, sharp, blunt,
 in-your-face – or maybe up-your-nose.

At a rehearsal you might hear
a glorious cacophony of instruments:
the raucous, full-throttle, throaty rattle
of disharmonious, earnest, plaintive, beseeching voices;
notes and words clashing, colliding,
in ranting, racing, mixed metaphors.

It's all intended to assault the senses,
to provoke reaction, and deliver satisfaction.
Stuff is on the hoof:
spontaneity is at a premium –
it gees up the punter . . .
gets 'em moving, man!
What's to beat the heat and pulsing power of a manic
jazz rehearsal?

In the early years of the twenty-first century, with the help of a friend I renovated and restored the outbuildings at Crisping Park in Barley Lane, which had been retained when Crisping House was sold. I also became very involved in various writing and performance projects, some with university students.

By **2009** I had attended wide range of poetry workshops and given several performances. In particular, I recall a workshop led by the poet James Harpur in Exeter Cathedral in 2001. As a result of this workshop I produced my first publication: a small volume entitled *Cathedral Poems*. James read a poem of mine called *Godwin* on local radio, which gave me great pleasure. Here is that poem and another from the same publication:

Godwin

Not yet of age
but sage in terms
of music made
and played
in Canterbury
and Exeter
good Mat Godwin
died.

A genius
who'd been
music master
at seventeen,
he'd rehearsed his death

so many times –
candles flickering,
curtains shivering,
last notes quivering.

He knew the signs.
The coughing fits,
the trem'rous sweats,
and blood he spat
as Masses ended.
He knew the
sickness of the tolling bell,
and great reviving chorus swell.

He'd stand to watch and listen hard,
this brave Elizabethan bard.
But strength and weakness
brought him to his knees
when organ piped
the notes sublime,
written by him
in his short time.

Marble

It's not strange that marble monuments
should be so often black or white
and symbolise the gap that lies
between the here and now, the light,
the fading then, the dark that was.

It's not strange that marble's used to show
 a polish, give a sheen, to one who'd been
 a gardener in a barren yard,
 where light was harsh, the surface rough.

It's not strange that marble may in turn
 become a broken column, or an urn
 draped, shrouded with a folded cloth
 to commemorate a common man.

It's not strange that marble's used
 to grace the grieving female figure,
 head nodding bravely poppy-wise
 and sighing with each sickle slice.

It's not strange that marble's used
 to smooth out jagged sorrow's edge,
 reflect bereavement in its face,
 let the living find death in place,
 hard, cold, durable; in marble.

In around 2004 I attended a jazz singing workshop run by Helen Porter at Stourhead, and there I met more interesting and talented people, and honed my singing skills by attempting to perform songs like *Old Man River* and *Fly Me to the Moon*. The last evening of this course was especially memorable. One of the participants, a man named Hopkins, rose quietly from the dinner table and recited brilliantly from memory a passage from *Under Milk Wood* by Dylan Thomas.

I was told later that Hopkins was a close relative of the actor Anthony Hopkins. It was this prayer, offered up by the Reverend Eli Jenkins, which he chose to recite:

Every morning, when I wake,
Dear Lord, a little prayer I make,
O please to keep Thy lovely eye
On all poor creatures born to die.

And every evening at sundown
I ask a blessing on the town,
For whether we last the night or no
I'm sure is always touch-and-go.

We are not wholly bad or good
Who live our lives under Milk Wood,
And Thou, I know, wilt be the first
To see our best side, not our worst.

O let us see another day!
Bless us this holy night, I pray,
And to the sun we all will bow
And say goodbye – but just for now!

Away from Dartington, I continued to find inspiration in visits to the Czech Republic, and in 2003 Joy and I enjoyed a wonderful holiday in Canada and the USA with recently-discovered second cousin Barbara Roy and her husband Reg. That experience gave me new insights into the lives of some of my Germon ancestors, and into the history of the USA – especially its tradition of Thanksgiving.

The celebration of Thanksgiving was central to a poetry recital entitled *Across The Pond* which I later staged as part of the University of Exeter's 'In Pursuit of Poetry' event. The following poems featured in that programme:

Westward

Westward flew the cockney sparrows,
pigeons, linnets, crows, hawks and jays,
spurred by hunger, poisoned arrows
of politics and narrow ways.
They sought a roosty-homestead land,
where their beliefs would not be banned.

With zest they'd fly,
freeboot through a lone-star sky,
or feather-cruise to Colorado,
Oklahoma , Idaho.
They'd pitch where old New York still grows,
wade in wide Missouri's flows
and tread the steps of Washington.

Beyond Lake Huron, over Nelson,
Athabascar, Saskatchewan,
toward Great Slave and Bear they went,
trailing, railing, giving vent,
their old frustrations disappearing,
golden sunsets ever-nearing.
The past retreated and memory palled;
the present task – and future – called.

Here no crafted net, no keeper's snare,
and freedom's fruit's beyond compare.
Gone, the fetter and the fence,
gone the cuff, the bluff pretence.
There's independence to be had –
as long as beak and claw stay glad,
ready with eye and ear to warn
of danger lurking in the corn.

The invitation's brash and bold –
'Write the stories not yet told;
create a place where courage grows,
where fledgling young will face down foes;
where nature beckons with its song,
where all may flock and all belong;
where Stars and Stripes and Maple Leaf
bind up old grief, instill belief'.

Westward to the sun's late rising,
Westward to the late sun's setting,
Westward whilst old east romances,
Westward where new freedom dances.

The Flag

There are stars in their eyes
as they reach for the prize
of freedom's great dawning.

To the sound of war's pipes
they have earned their glad stripes –
through struggle prevailing.

They have set up their flag
on the hill's highest crag –
this message announcing.

'This land is for doing;
for giving, receiving;
believing and being!'

By the year **2019**, much had happened. With the help of my teacher and friend Lily Neal I had written and published two books of poetry, *Czech Spring* and *Poems at an Exhibition*, organised and delivered a short series of lectures at Exeter University called 'In Pursuit of Poetry', and won the University of Exeter's Paddon Award for a poem called *Big Bang*. Here, unaccompanied by acoustics, is that poem:

Big Bang

Silence there was.

Then chaos came with smoke and flame,
lightning, forking and streaking.
Vile gases formed mushroom clouds.
Sulphurous molten matter
spewed like molasses
to become dark tenuous finger-lakes
all sprayed with starburst showers
of primal dust.
All cooling, coalescing
into a finite mass.

Heavy, violent heaving there was;
pushing, shoving, grinding, grating,
implosion, explosion;
prime-sound-noising –
the big, BIG BANG –
with its thunderous raging and roaring
firework-screeching, wild whining,
bawling and howling,
tumultuous, inert, bashing and crashing.
Raw noise.

Sound in its totality.
Sound, in all its forms;

with all the pitches, notes, rhythms, chords,
and all the 'potential-for-hearing'
that ever could be.

Sound to be bundled away,
embedded in the cosmos;
a raw, invisible resource;
a priceless sonic-field,
silently waiting
for men to evolve

from the mud and slime of time,
to find the ear, the tool, the will, the way,
to tap and work creation's lode; –
release prime sound in music's form
and take a 'need-to-listen' world
by storm.

I had also collaborated successfully with a student friend called
Emma Baker, writing and performing shows called *New
Horizons* and *Moments in Time*. We even sang a few of our songs
at an 'open mike' session in the Exeter pub called The Angel.

I have enjoyed singing with various choirs: the Exeter
University Choral Society, an *a cappella* group called 'Take
Note', Exeter School, South Devon and Ottery St. Mary Choral
Societies, the Exeter Music Group and the Isca Ensemble. (In
October 2019 I took part in a performance of Haydn's *Creation*
with Isca in Exeter Cathedral).

More recently, on 7th December 2019, I sang in Karl Jenkins' *The Armed Man* and Vivaldi's *Gloria* with the Exeter Choral Society.

Here are two poems: the first, *Love at the Opera*, was written for the Choral Society and the second, *Take Note – go for A Capella!* for the *a capella* group.

Love at the Opera

Love is the key that
Opens up the soul's sequestered thoughts.
Virtue often seeks to be its friend;
Each will the other oft defend.

And, when the plot requires it,
The two will pledge fidelity
To all they see as truth.
Hear how the tenor
Embellishes the score.

Oh! how his leading lady leads –
Portrays life's nuances of shade and light,
Enlists the aid of day and night.
Rejoice ye all, cause bells to ring –
Applaud love's power; and hear it sing!

Take Note – go for A Cappella!

Take note, songs have something to say.
They cheer us when the skies are grey,
revive our spirit when it's low;
and tell us, 'Yeah! Just go, go, go!'

We hear *The Blackbird* in the dead of night
and we remember *Yesterday*.
If we *Let It Be*, it'll be all right;
we'll be *Feeling Good* every day!

Taylor Swift-ly fills *Blank Spaces*;
Here Comes the Sun brings smiling faces.
Chasing Cars may hold attraction,
but *Only You* can find your satisfaction.

And So It Goes – you've gotta
Wade in the Water, Children!
Take Note, get singing *a cappella*
with the other girl or fella.

And So It Goes – you've gotta
Wade in the Water, Children!
Take Note, get singing *a cappella*
with the other girl or fella.

It became obvious that the second decade of the 21st century was, if anything, to be more eventful than the first for me. My artistic involvement at the university was at its peak. With the Exeter University Choral Society I sang in front of the new Forum building in a special anniversary concert to mark the visit of Her Majesty the Queen. At that time the inimitable Marion Wood was the university's Musical Director. Her appointment had proved to be an excellent decision.

She was a multi-talented, ambitious, enthusiastic and innovative leader, and a good friend and teacher to many people throughout her years at Exeter. It was through her efforts that Choral Society members were able to take part in performances of *Carmina Burana* and *West Side Story* at the Northcott Theatre. Both were memorable events.

It was Marion who introduced me to the student Emma Baker who became a friend and with whom I shared a productive collaboration for several years. Marion was also the director of the Exeter Music Group (EMG), which was tailored to fostering local amateur musical talent. The EMG concerts featuring the music of Mahler and the *Sea Symphony* by Vaughan Williams were excellent.

Contacts with the university led me to take part in a great performance with Mike Westbrook and his band at Seale Hayne, Newton Abbot, of the musical *Glad Day*, which is based on the poetry of William Blake. Here is the poem *Prophet* which I wrote around this time.

Prophet

Prophet, prophet, turned to dust
in the darkness of earth's crust,
what great spirit, vision, thought,
now hosts the treasure thou once brought?

In what mind-blown time or place
glows the firegold of thy face?
In what way dare we pursue?
What the brain to gain the clue?

What the finger and what hand
could craft the 'being' of this land?
And when the land begins to pall,
what dread cry? How deep the call?

What the sword and what the lance?
In what war-game is our chance?
What the armies, what dread might,
will the undreamt weapons fight?

What the peace and what the calm?
In what ointment is the balm?
What the solace? What the pill,
will those inborn fears still?

When all gods together cleave,
to wipe all tears with their sleeve,
will He be there – who prophesied
that lamb would lie at lion's side?

Prophet, prophet, turned to dust
in the darkness of earth's crust,
what great spirit, vision, thought,
now hosts the treasure thou once brought?

Other concerts which I remember well are those to celebrate the music of the Exeter composer William Jackson, conducted by Geoffrey Brace, and Dyson's *Canterbury Pilgrims*, conducted by Stephen Martin.

Most public performances require a box office and involve devices to amplify musical sounds. At the studio I was inspired to paint two pictures, which both owe their existence to the recycling of cardboard boxes from Morrisons, one called *Box Office* and another called *Loudspeaker*.

They appear on the next few pages.

Box Office

For many Victorians the pub, the music hall and the theatre presented opportunities to forget, for a while, the harsh realities of long working days in factories, offices, shops and workshops, and the ever-pressing need to make a living. On Friday or Saturday nights they would queue, shillings, florins and half-crowns in hand, to buy tickets for the current show; often this involved murder, mystery and much melodrama.

As they snuggle into their red plush velvet seats, the stage is set, the curtain rises. The lights are dimmed.

Act One, Scene One . . . a rectangular table of bare pine, three empty wine glasses, three wooden chairs (one turned over and lying on the floor). An elderly man, pale, bearded and dressed in black lies on the floor near the chair. His head rests in a pool of blood. Two younger men, also in black, stand at opposite ends of the table, confronting each other.

The journey begins. With relish, the actors begin to pull the strings . . . life, death, fear, disbelief, curiosity, anxiety, hope, despair: all are here, lived with, in the darkness of the auditorium, through imminent night and shadowy tomorrow days.

'All the world's a stage . . .'

Loudspeaker

I am a box of electrical components,
activated by a microphone.
There is a switch to control the sound
which I emit, put out.
Mainly, I'm required to shout.
You will see me front of stage,
where I lead the rave, back up the rage.

Before the decline of communism,
thousands like me were employed in Eastern Europe.
But we lost favour.
New big mouths, big ideas and big brothers
were found in the kitbags
of capitalism and technology.

As a species, we still exist.
We appear at gatherings, aiding and abetting
ranting, raving, sad misbehaving.

But these days we feel squeezed, somewhat unloved.
There is much whispering and 'taking the mike'.
Electronics are on a high.
Perhaps it's time to shut my mouth –
Or turn myself green and get on a bike?

In the early years of the new millennium I started working on a musical show based upon my experiences as an undergraduate in the years 1968 to 1971. It was provisionally titled *Now the Day!* and still lies unfinished in my desk. I hope to revisit it before my 90th birthday and am very conscious of the fact that 2021 will mark the 50th anniversary of my graduation!

In February 2010 Luke, our grandson, married his lovely wife, Ann-Louise, in Norway. The snow was thick on the ground and we all enjoyed an unforgettable weekend. I wrote the following poem for the newly-weds:

Song of Norway

The two of you, on a Norwegian beach,
boats bobbing beyond the shore's far reach;
fjords' fingers get lost, and found,
mountains rise to the sky they seek.
To love's own special sound,
well-pondered, potent words you speak –
a single life's loud silence break.

On ever-shifting sea-worn sand
there in the summer sun you stand,
before the North Sea's quickening tide.
You squeeze, hold tight each other's hand
beneath warm skies of truest blue,

you see, in other eyes, the truest you –
you know wherein the future lies.
You spread the news across the sea
Ann-Louise Luke's bride will be!

The message comes to cast a spell
And bright the mood in a Czech hotel.
Love's strange music pervades the air,
and I recall that long ago, in Troldhaugen,
close to fjords, glimpsed through sun,
an earlier couple pledged their troth.
Young Edward Grieg and Nina, both,
back then, in eighteen-sixty-one,
were set to tie the marriage knot.

Unwittingly they set the scene
For a nineteen-forties music plot.
Song of Norway appeared on page;
eventually it took the stage
in London, and was all the rage.

In this rather different age,
the beat is mod, the lyrics change.
Love's music seems not quite so strange.
The *Song*'s fine sentiments remain,
yet it alone cannot contain
the myriad things we wish for you.
Most of all, may you be happy,
your married love be ever true.

It was later the same year that I attended a Czech language course in Brno at Masaryk University. The following poems are two of the ones I wrote at that time, which, with translations into Czech, were recently published in a book marking the centenary of the founding of the University.

Eulogy to Harmony

At the Faculty, in Anna Novakova,
in a room at the back of building B,
students listen hard to learn the sounds
and phrases of Slavonic words.
They practice Czech.
They practice Czech.

There's nothing slack
about the way they face this task.
They're not afraid to ask
the teacher to explain, again,
the nuances of gender, case.

In the sunbathed courtyard,
with its cobbles, trees
and cool grasses,
they take a break;
they take a break.

They sit on scroll-shaped benches
or utilise a work of art.
Some smoke;
some smoke.

They talk excitedly
in a multiplicity of tongues,
creating curious conjoined chords,
a musical flow of world-wide words;
a universal *Má Vlast* suite,
that, many times, they will repeat:
their own especial eulogy
to never-ending harmony.

The sun goes down on Brno

The sun goes down on Brno –
there's light still in the west,
but darkness gathers to the east
and bids the eyelids rest.

The sun goes down on Brno –
the traffic noise recedes.
The hotel room starts closing in;
it's sleep the world needs.

The sun goes down on Brno –
there's sadness in the air.
The lights go on, the curtains hang,
the window is left bare.

The sun goes down on Brno –
and soon most Czechs will sleep;
to dream perhaps of Masaryk,
or Švejk, the soldier lying deep,
or Švejk, the soldier lying deep.

2013 saw the publication of my book *Czech Spring*. This was launched at an event held in St Stephen's Church, Exeter, which included readings interspersed with Czech songs, music and the drinking of *slivovice* (Czech plum brandy).

Two years later, with a small team of students, I presented *Poems at an Exhibition* (a group recital of the poems which were later to appear in my second book) at Exeter University. It was a well-received inaugural performance.

In 2016 I proudly supported the Leave Campaign in the Referendum and played a small part by writing, under the pseudonym of George Julius, a leaflet setting out my views. These views are reflected in the three pictures and accompanying poems which are on the following pages.

This activity occurred after I had suffered a long period of ill health. In 2014 I had been diagnosed with Burkitt Lymphoma. Eventually, thanks to the Royal Devon and Exeter Hospital (especially the Haematology Department) and the Exeter cancer charity FORCE, I made a good recovery toward the end of 2015.

Our extended family continued to expand. In those years several great-grandchildren were safely born and welcomed into the world. The second decade of the twenty-first century appeared to be full of promise.

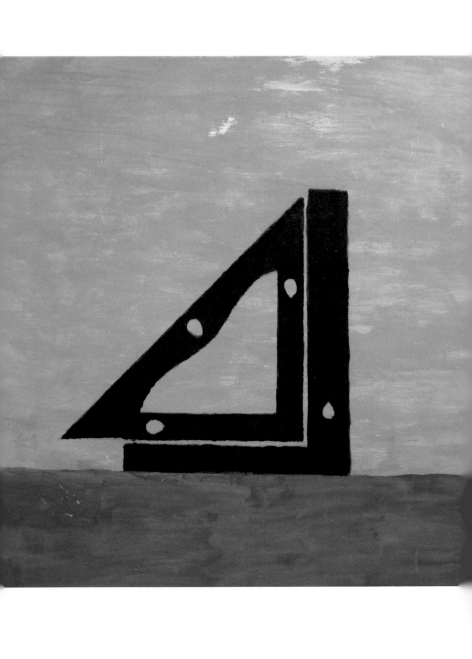

Set Square

Set square the sail, boys!
And let the doubters know
that British men are not content
to fish in seas sore plagued with regulation.
We will avoid such strangulation.
We'll journey North, South, East and West
to find good fortune for our nation
and trade on terms of the very best.

Good British words will flourish worldwide.
We'll ride the wave and brave the storm;
from natural hazards we'll not hide.
Smiles and handshakes will be the norm.

Fear and trepidation court defeat,
But, if four-square we stand, our future's bright;
take back control, assert that right.
Let's sail from darkness into light.
Extol the virtues of our land.
Four square we'll sail.
Four square we'll stand.

No Piecemeal Britain

Great Britain is this country's chosen name,
but there are some who hesitate to make this claim.
They would like to put the clock of history back
to the time these islands were bereft
of unity and prosperity.

United Britain forged an Empire wide,
firmly built on a bold inception
and a tide of revolution
in industry and trade.
A waiting world bought goods
all stamped and marked with pride:
Made in Britain.

This country caused commercial wheels to fly,
and populations multiply,
and Britons stood together as a nation
to keep the freedoms they had won.
Again, they need to be as one;
play deaf to calls for separation.

Straight Talk

Straight talk . . . pale sea-green, tinged with blue
and edged with wholesome brown,
is of the earth, yet unsullied.
It is born, washed and clarified,
in the tides of common discourse.

Words, chosen and delivered
with precision, are not ambiguous.
There is no show.
Steady, ever-steady, the communications flow.
No spin, no covert nod or wink,
no surreptitious grin,
no flirtatious self-abasement.

Straight talk moves determinedly to the edge,
to deliver a clear, concise message
in thoughtful and purposeful utterance
that warms the ear of the most dubious listener.
The language is pale sea-green,
tinged with blue and edged with brown;
it is seldom flamboyant.

And seldom will it let you down.

Our extended family continued to expand. Several great-grandchildren were safely born and welcomed into the world. The second decade of the twenty-first century appeared to be full of promise.

In September 2017 I managed to attend a creative writing course in Garsdale, Cumberland, not far from the village of Troutbeck where I had stayed on holiday in 1954. The place inspired a painting and a poem entitled *Cumberland Gap*.

Cumberland Gap

It is a mid-afternoon in July 1954.
Three young men arrive
at a genteel guest house.
Tea is served on the terrace.
Across the valley a steep green hillside beckons.
The men climb towards the summit.
No clouds unfold.
There is no burning in the sky.
There are no rumblings –
no chariots in sight.
Feet keep moving forward;
there is no stumbling.

'Not far to go, not far to go!'
they cry. But what about Jerusalem?
Jerusalem? Oh, yes! Sing, sing, of old Jerusalem!

Sheep drift in flocks across the hills.
Lambs bleat loudly for their mothers. Evening stills,
and, as in ancient times, the world moves on,
prepares, for the feet of countless others.

For me the Garsdale experience was ameliorative, but more
importantly in the Autumn of 2019 a memorable diamond
wedding celebration helped both Joy and me to end the year
in good spirit.

It was a truly lovely evening. Here are two of the poems
which were included in the card with which we welcomed all
our friends and family:

Diamond Moments

See how this stone
glistens in the summer sun.
There is no sign of its black
carboniferous ancestry –
only mysterious delight
seen through streams
of all-revealing light.

A band plays in the square –
around midday, at summer's height.
It's a Wonderful World,

One moment in time –
forever there.

The cast of *Brassed Off*
stirs from nowhere, emotions
which wring the socks off
the hard-faced, tight-laced.

The teacher in the classroom,
feels a special moment pass,
beaten by the bell.

An out-of-breath student rushes
to the bus station in Brno;
for a moment she touches the strings of history –
and the music never lets go.

A row of children stands
on the low sill of a large window
facing the world outside,
both hands raised as if in praise,
glad to embrace
life's will.

Butterfly wings flutter,
the world sings, people cry.
Kahlo is Kahlo –
her paintings sparkle
in a diamond's
all-revealing light.

The next poem has become a firm favourite with many of my friends and relatives.

I need no telescope . . .

I need no telescope to see,
out there in night's dark space,
a little cluster of bright stars
which is my own especial place;
a world that is, once was, will be.

I gave these shining ones their names
and now they cluster in new light's way –
part of a firmament that plays strange games
with me by night, sometimes by day.

For I have seen my bright-star son
overwhelmed and swallowed whole
by a sinister black polar hole
and my grieving has only just begun.

I need no telescope to see
the hole that's left for me to fill.
For who, now, will walk with me
and talk about those things
that only he and I could see?

In the spring of 2017, around the time of Richie's funeral, the following poem almost seemed to write itself:

The Rose of Memory

The rose of memory
grows in us from birth.
A seed is set in human earth
and blessed with vital nutrients,
experiential incidents.

And soon a new plant rises up:
roots and shoots convey fresh sap
and stems grow strong, for purpose fit.
In time, each budding flower is lit
in pink, or white, or yellow, red.
By *life* the flourishing plant is fed.

And when this rose is in full bloom,
with every petal open wide,
it can illuminate the darkest room –
and push all veils of age aside.

Its scented breath can bring
fresh colour to the palest cheek
and cause the faintest heart to sing.
Oh, how this precious rose can speak!

All that you have seen and read so far is a part of an ongoing pilgrimage to the memory of, and in honour of, the dear son for whom I once wrote poems. My first poem for Richard was called *From ABC to PhD*.

Here it is, followed by the poem which celebrated Richie's 40th birthday:

ABC to PhD

Remember how it felt to go to school,
to do the sum and get it right;
to play the fool when out of teacher's sight?

Remember how it felt to write your name,
to add, subtract, divide and multiply,
to play the game, and use the words that clarify?

Remember how it felt to be an undergrad,
to ponder what, and why and how;
to do what's *trad* occasionally, just then and now?

Remember how it felt to struggle, fight;
to keep on course and reach the goal,
to outface night and not let set-back take its toll?

Remember how it felt to achieve your aim,
to stand up tall and breathe success,
to savour fleeting fame
and, momentarily, the world possess?

Forty Years Rich

For you a birthday sonnet now I write.
Oh, yes, in fourteen lines I will recite
resounding rhymes to praise and celebrate
the day you came to us: March 6 the date.
You, dimpled, long, and very sound of lung;
you, yawning as the visit bells were rung.
Eyes wet sometimes, we watched; we saw you grow,
attend the schools, in earnest get to know,
remember countless things and dare to think.
So, Pinkney-primed, you sought to reach the brink.
Rich in talent, as in name, you've always been:
in craft and art, fulfilment you may glean.
Cheers now, dear Rich, from all down west.
Happy birthday! May you and yours be truly blessed.

From the moment we heard of his death in the spring of 2017, Richard has never been far away. He is present in many of the hundred or so pictures which I produced and exhibited in the studio at Crisping Park in September 2018. His 'presence' led me to redesign the rear garden of our house in Polsloe Road and to add a new studio outbuilding, in which I hope to exhibit the paintings on stone made during the first part of my pilgrimage.

Recent years have also seen the passing of several near and dear ones: my sister Marjorie, my brother-in-law Tony and my cousins Hazel, Maurice and Charlie. It seems that all, in time, is lost; everything must go.

But pilgrimage is not in vain. Through a series of actions, carefully considered and undertaken in hope, at a time that is special, progress can be made. The careful placing of one foot in front of another, enjoying the best of all that comes our way, knowing that we are blessed, enjoying to the full every magic moment, can give us momentum to move forward with confidence and optimism, into the next decade.

Thank you for your company; may your cup be deep and, indeed, often overflowing.

I conclude with my last poem for Rich, and, for everyone who had the pleasure of sharing time with him.

Time's Embrace

The bell is tolled; the choir sings.
To Time's embrace the world clings.
Time is Life, and Life is Time.
And everything exists in Time.

Time, an all-embracing birthright treasure –
the Big Bang's countervailing measure –
is the basis of all matter.

Time allows the rain to fall,
the sun to shine, the clouds to scatter,
Empires to grow – and then decline.
Time lets words flourish line on line.

In Time, amazing dreams are dreamed
– for a breaking dawn to shatter –
yet, with hope and patience, they're redeemed.
Time is the essence of the matter.

In Time's amazing fullness,
men, burdened with their sinfulness,
perceive that they are destined to conceive
and gain eventual wholeness
through progeny, waiting in the wings.

In Time it seems, all needs are met,
future goals determined, set;
and there is nothing to regret,
when all love's rooms are fully let.

Envoi

And So It Goes

When exhibitions are over, done,
and earthly treasures fade;
when the brilliant sun
finds its rest in shade;
when frailty, with a knowing smile,
limps, or plods, towards the door;
when there are no words, no nods or winks
that call for an extra mile,
and there is nothing further to explore,
then, life's free time
– so generously given –
will find its own safe resting place
in memory. But a story, unwritten,
is ready, waiting to be told
by a friendly, smiling face,
a tongue that is a golden pen,
so times long gone can live again.
Then raise the cup, propose a toast
to everyone who's been your host.

And so it goes . . . amen, amen.
And so it goes . . . amen, amen.